Silent Places

SILENT PLACES

Landscapes of Jewish Life and Loss in Eastern Europe

PHOTOGRAPHS AND TEXT BY

Jeffrey Gusky

INTRODUCTION BY JUDITH MILLER

OVERLOOK DUCKWORTH

Woodstock • New York • London

FOR MY FRIEND AND GUIDE,
RENATA ZWODZIJASZ

Published in association with Ronald Lauder

First published in the United States in 2003 by
The Overlook Press, Peter Mayer Publishers, Inc.
Woodstock & New York

WOODSTOCK:
One Overlook Drive
Woodstock, NY 12498
www.overlookpress.com
[for individual orders, bulk and special sales, contact our Woodstock office]

NEW YORK:
141 Wooster Street
New York, NY 10012

LONDON:
Duckworth
61 Frith Street
London W1D 3JL
www.ducknet.co.uk

The author wishes to thank Columbia University Press for permission to quote from
Holocaust Journey: Travelling in Search of the Past by Martin Gilbert in the caption for
"Idyllic Illusion"; the Indiana University Press in association with the U.S. Holocaust
Memorial Museum for permission to quote from *Anatomy of the Auschwitz Death Camp*
by Raul Hilberg in the captions for "Birkenau Barracks in Winter" and "Man in the Fog";
and John Wiley and Sons, Inc., for permission to quote from *Jewish Heritage Travel:
A Guide to East-Central Europe* by Ruth Ellen Gruber in the captions for "Shattered
Synagogue Window" and "Roofless Splendor—Eighteenth-Century Synagogue."

∞ The paper used in this book meets the requirements for paper
permanence as described in the ANSI Z39.48-1992 standard.

Cataloging-in-Publication Data is available from the Library of Congress.

Book design and type formatting by Bernard Schleifer
Printed in Spain
ISBN 1-58567-316-1 (US)
ISBN 0-7156-3254-X (UK)
ISBN 1-58567-516-4 (US-pb)
FIRST EDITION
1 3 5 7 9 8 6 4 2

INTRODUCTION

THERE are almost no people in Jeff Gusky's images of southeastern Poland. More than three million of the country's 3.5 million Jews were killed in the Holocaust. Fewer than twenty thousand Jews remain in Poland, perhaps as few as ten thousand. Poland today is virtually "Judenrein."

Many of Gusky's pictures verge on the abstract. That, too, is appropriate. While the black-and-white photographs depicting slaughter on such a scale are irrefutable, they have not made it any more comprehensible. Photographs then and now, however, have helped make the collective obligation of remembering the fate of Europe's Jews all the more vital.

For decades after the war, Poland found it convenient to blame the murder of the Jews on neighboring Germany and the Soviet Union. But as Poland has begun confronting its past, modern historians, some of them Poles, have belatedly acknowledged that many Jews were killed by fellow Poles as well.

Poland was home to six industrial-scale concentration camps, including Auschwitz. They remain as ruins, new "tourist" sites, as terrifying today when built and operating. The spiritual presence and physical absence of their victims is captured in many of these ghostly images.

On July 10, 1941, 1,600 Jews, nearly the entire Jewish population of the Polish village of Jedwabne, were murdered by their Polish neighbors. In Jedwabne, where Polish Jews were falsely accused of having sided with the Soviets, local Poles, incited by Germans, took their revenge after the Red Army left. Though Polish responsibility for the massacre was established in 1949 when fourteen Poles were tried and convicted for the murders, the incident, like so many others in Polish history, was buried in archives and memory. The crime of Jedwabne was only recently resurrected in a slender book, *Neighbors*, by Jan T. Gross, a Polish historian who emigrated to New York. The book's publication has rocked Poland.

Scholar Michael Steinlauf, in his 1997 book, *Bondage to the Dead: Poland and the Memory of the Holocaust*, attributes Poland's persistent distor-

tion of its national memory not to the catch-all, and ultimately unsatisfying phenomenon of "Polish anti-Semitism." Yes, he writes, although Poland since the fourteenth century had been a relatively safe haven for Jews, anti-Semitic traditions were also deeply rooted. In the 1800s, long before Poles achieved their dream of independence in the form of a nation state, anti-Semitism served as the nationalists' ideological glue. In the 1920s and 1930s, radical right-wing nationalists and senior figures in the Catholic church encouraged a resurgence of the ancient hatred of the Jews, calling for pogroms, segregation of the Jews in the work place and universities, and the country's social and cultural life.

But many avowed anti-Semites were also among those who sheltered Jews on pain of death by Nazi edict. Yad Vashem, Israel's Holocaust museum, pays tribute to the Catholic nationalists who hid Jews in their homes to protect them from the genocide. Some saved Jews for money, but others out of sheer conviction that was happening was evil.

Steinlauf argues that Poland's amnesia lies partly in its self-perception as a noble, true, martyr nation and, outside of Poland, the unacknowledged victim of history. For centuries, Poland did suffer terribly at the hands of its more powerful neighbors. It was also the first country to oppose Hitler's demands, and as Adam Michnik reminds us, and the first to stand against Nazi German's aggression. Poland, he writes, "never had a Quisling. No Polish regiment fought on behalf of the Third Reich." As a result, hardly a single Polish family was spared by Hitler or Stalin. Three million non-Jewish Poles were killed by the Nazis and 1.5 million more were deported to the Soviet Union, half of whom never returned.

After the war, however, Polish Jews became reviled "competitors" in Poland's suffering. This was their unpardonable sin.

Today, anti-Semitic arguments, though increasingly marginalized, still appear in Poland's right-wing Catholic nationalist press and on Web sites—and, unfortunately, are echoed in remarks even by such figures as Lech Walesa. But Jozef Cardinal Glemp, the Roman Catholic Primate—once reported to have said that the Jews should apologize for collaborating with the Soviets between 1939 and 1941—has more recently spoken of the need for the church to ask the Jews for forgiveness. And the government's Institute for National Remembrance has been conducting investigations into the massacres at Jedwabne, and in other Polish towns.

Konstanty Gebert, a Polish-Jewish journalist and editor, has told the *New York Times* that younger Polish historians are beginning to write as if Poland were a "normal country." The phrase is telling. For despite the progress in rescuing truth from the country's national mythology, many Poles remain captive of a collective, invented past.

This is partly why Jeff Gusky's photographs are so moving. They are physical evidence of a past that can no longer be denied. He has traveled throughout the country, finding traces of the vanished Jewish communities. All those who participated in this disaster, whether Nazi or Pole, were thorough. Not content with destroying the living, they sought to obliterate even the memory of the dead. Chmielnik Cemetery, along with so many other Jewish burial grounds, were deliberately desecrated. Fewer than six gravestones remain, none of which is standing. Broken and neglected, they lie on the ground, overgrown with weeds and sorrow. Most of the gravestones, as Gusky notes, were ripped up by the Nazis and sold as building stones. In his photograph, a new housing development rises just inside the cemetery's perimeter.

Synagogues in Krasnik, Przysucha, Dabrowa Tarnowska, Wielkie Oczy, Koszyce—places where Jews once celebrated life and mourned the dead—lie in ruins, just as the Nazis left them. Poland's recent restitution law has returned them to the local Jewish communities, but there are no longer Jews in most of these places to maintain or restore them.

The Jews of Poland can live on only in the memories of Jewish survivors of the genocide and of fellow non-Jewish Poles, provided they begin caring for these precious fragments of the communities that were extinguished by hatred and fear. That is why Jeff Gusky's book of photographs—and dozens of other individual efforts born of confusion, curiosity, and sorrow—are so critical if Poland, along with so much of Eastern Europe, is to retrieve its Jewish past, and its own.

—JUDITH MILLER

Author's Introduction

In 1995 I heard a radio interview with Ruth Ellen Gruber, the author of a new book titled *Jewish Heritage Travel*. A United Press International correspondent stationed in Europe when the iron curtain fell, she vividly described vestiges of a lost world largely hidden from western eyes by a half century of communism, frozen in time by geographic isolation, poverty, and the absence of living Jews. I found myself spellbound by her eyewitness account of the remnants of the millennium-old civilization of Eastern European Jewry destroyed by the Nazis and their collaborators, the remnants ignored, at best, by the communists.

At that time I was living on a beautiful lake, in a hilly and densely forested area in east Texas and, at the same time, working as an emergency room doctor. I was able to balance my life as a doctor with the remote location of my house because I had learned to fly small airplanes. Using a nearby landing strip, I could on short notice get to any of the several dozen hospitals across Texas and Oklahoma for which I was on 24-hour standby, and help solve emergency department staffing crises.

I came to use the plane like a car. I could fly to Dallas, 120 miles away, for groceries, to get a haircut, or to pick up a date. On a whim I could hop in the plane and go essentially anywhere in the continental United States; life was an adventure. But still, I was single, and I was Jewish and, at forty-three I was beginning to ask myself "how important is it to me to marry a Jewish woman and raise a Jewish family?" I pondered a trip to Israel in search of answers to these questions.

Listening to Ms. Gruber on the radio helped me to realize that what Judaism meant to me was something about the ethic of family and survival against tremendous adversity. I decided to go not to Israel but to Eastern Europe in pursuit of answers to my quest. I would go to the area where the story of *Schindler's List* actually took place and seek out Jews who survived the

Holocaust, perhaps to discover more about what Judaism meant to me. I would go in the harshest part of winter to attempt, in small measure, to comprehend the incomprehensible suffering sustained by individuals and the mutilation and destruction of their families and communities.

As an American, I was accustomed to seeing old buildings of architectural or of historic importance restored and often preserved. I was not prepared to encounter so many centuries-old sites of Jewish history in the raw, abandoned, neglected, disintegrating. My greatest surprise, however, was that in the four journeys to Poland, I did not encounter a single Jew, only emptiness, only absence—although I certainly could have found inhabited pockets in Warsaw with an effort. Nazi genocide and its aftermath had done its work well. But the sites I visited, once full of life, were silent.

When this project began in December of 1995, I must confess I knew very little about high-end photography. A few weeks before my first trip to Poland, reacting to a hunch, I decided to purchase a 35 mm camera and black-and-white film. I called B & H photo in New York City, the world's largest professional camera store. B & H is staffed by orthodox Jews. Many of the helpful experts with whom I spoke had lost relatives in the Holocaust and were personally moved by my upcoming trip. Upon their advice, I purchased a single, professional quality 35–350 mm Canon zoom lens and camera. I read the instruction manuals on the plane en route to Eastern Europe. I had no sense that my life was on the verge of phenomenal change. By April 2002, I would have an archive of some 12,000 negatives.

On my first day in Poland I visited the site, on the outskirts of Cracow, of the former Plazow concentration camp. I was told that the Nazis leveled the camp before the end of the war to eradicate all traces of enslavement and mass murder, thereby concealing their crimes. At first glance, only a grotesque, concrete, Soviet-era monument marked the site of the camp. For some reason, I felt prompted to ascend a hillside in knee-deep snow moving in a direction away from the monument.

At the top of the hill, I came upon an abandoned brick building surrounded by the remnants of a high, war-era barbed-wire enclosure. Inside the building, I found a large, empty room with bars on the windows and some adjacent smaller rooms that could have been guard's quarters. The building overlooked the enormous rock quarry depicted in the movie, *Schindler's List*.

I walked into the large, dimly lit main room and felt surrounded by something ghastly and horrifying. I later learned from Thomas Kenneally's book, on which the film was based, that this building was probably the Austrian Hill Fort, a dreaded place where people were tortured and executed.

I attempted to capture what I felt with my camera. This is how work on

Silent Places began. It is also where I first learned that my photographs could be informed by my emotions.

As the project evolved, I taught myself through self-study and much trial and error how to make my own prints from black-and-white film negatives. Over time, I've tried to refine some intuitive sensibility and a developing technical understanding about photography into a record that has a sense of connection with the murdered people who once inhabited these landscapes. Seeing light, shadow and form almost as an aspect of history is what grew in me, so that I could access it personally and technically, almost automatically, when I shoot.

Just before 9:00 A.M. the next morning, I took a cab into the heart of Kazimierz, the historic Jewish quarter in Cracow. At the restored fifteenth-century synagogue, I was met by a professional tour guide, a stunning, sophisticated Polish woman who greeted me in perfect English, with a warm smile.

I had just met Renata Zwodzijasz, who would help change the course of my life. Without her help these photographs would not have been taken. She was the most unlikely person for a guide. Renata had a Ph.D. fellowship in plant genetics, acquired in Missouri of all places, during the late '70s, but had chosen to return to her homeland despite the privations and repression of the communist era. A few years later she left her field for the better pay she could earn as a professional travel guide.

Each time in the ensuing years that I returned, Renata accompanied me into the Polish countryside and into a virtual time machine. Prior to the Nazi war against Eastern European Jewry, Southeastern Poland was heavily Jewish. The majority of villages and towns, in fact, were home to a Jewish community.

Jews usually resided close to the town square where commerce was conducted. Synagogues were usually close by as well so that, in accordance with Jewish tradition, worshippers could walk to the synagogue on the Sabbath.

Using an out-of-print book written by an Polish academic after the war documenting the architectural remnants of the former Jewish communities, we scoured the countryside to find former synagogues, cemeteries, parks, schools, houses, shops, factories and more. Often, we depended upon the kindness of older people who lived in a particular community during the Holocaust to tell us where to find the vestiges of prewar Jewish life. Not knowing them or "their war," I hoped they had been kind then. This is how the voyage began, that has led to this collection and this memory of these silent scenes.

—JEFFREY GUSKY

SILENT PLACES

Park in Former Jewish Enclave,
Ustrzyki Dolne, Poland, 2001

Before World War Two about seventy-five percent of this town's five thousand residents were Jews. Nearby, the large former synagogue is now in use as a public library.

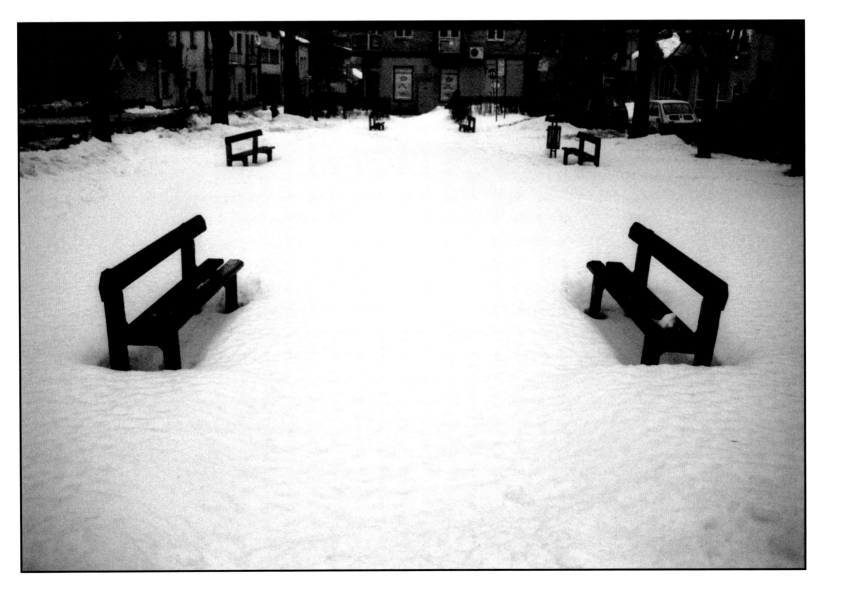

Idyllic Illusion, Izbica Lubelska, Poland, 1996

The historian Martin Gilbert wrote, in *Holocaust Journey: Traveling in Search of the Past*, that "at Izbica some of the most horrendous scenes recorded in the Holocaust, or indeed in the Second World War, took place." Just across the tracks from this train station was an open-air transit camp covering approximately one square mile. "The area was completely covered by a dense, pulsating, throbbing, noisy human mass. Starved, stinking, gesticulating, insane human beings in constant, agitated motion . . . the Jewish mass vibrated, trembled, and moved to and fro as if united in a single, insane, rhythmic trance. Hunger, thirst, fear, and exhaustion had driven them all insane." Prisoners were held here awaiting transport to Belzec.

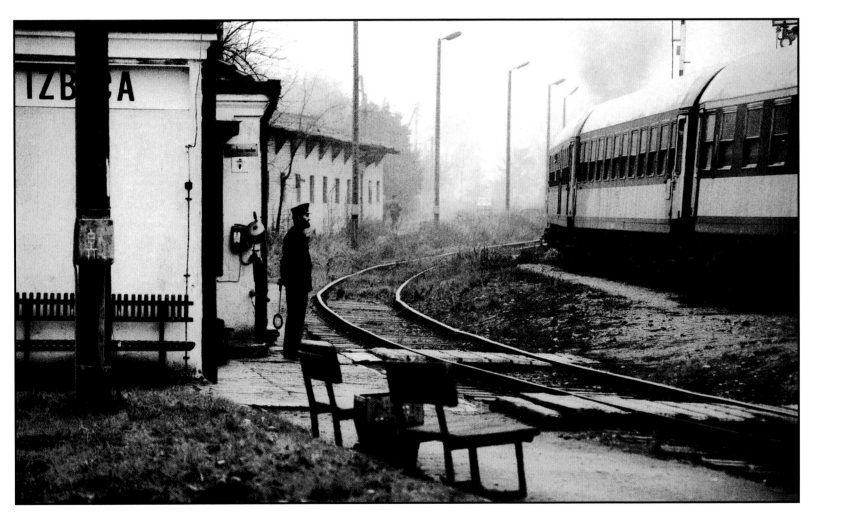

**Swastika Graffiti on Izaaka Street
in the Former Jewish Quarter**, Cracow, Poland, 2001

In his 1938 photograph of Izaaka street, Roman Vishniac captured the animation of daily life in this former Jewish Quarter with Jewish men and women clad in traditional dress walking hurriedly to and fro during a snow storm.

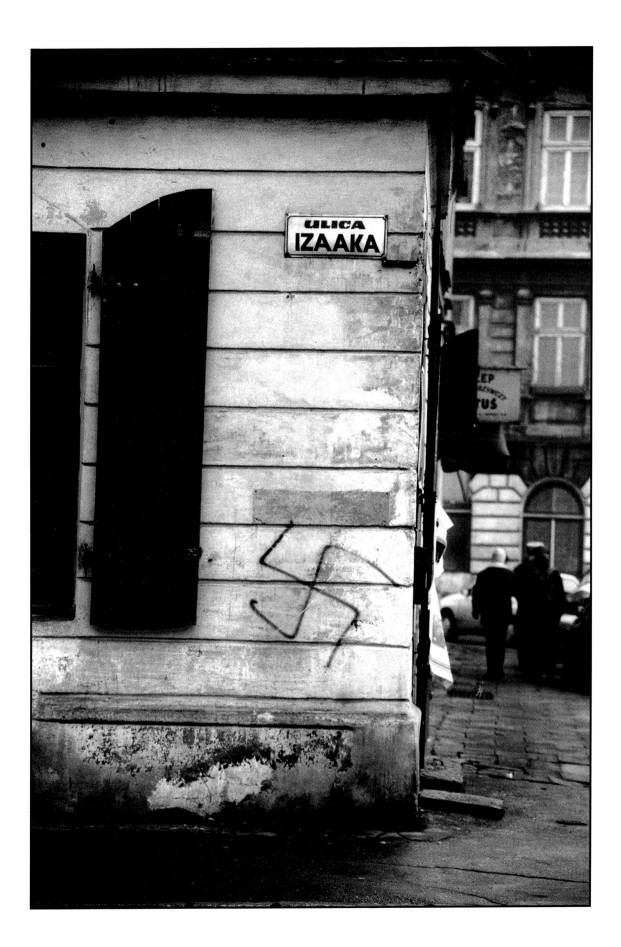

Jewish Gravestones as Building Material,
Cracow, Poland, 1999

This nondescript wall on a side street in Cracow's former
Jewish quarter was built, in part, with Jewish gravestones.

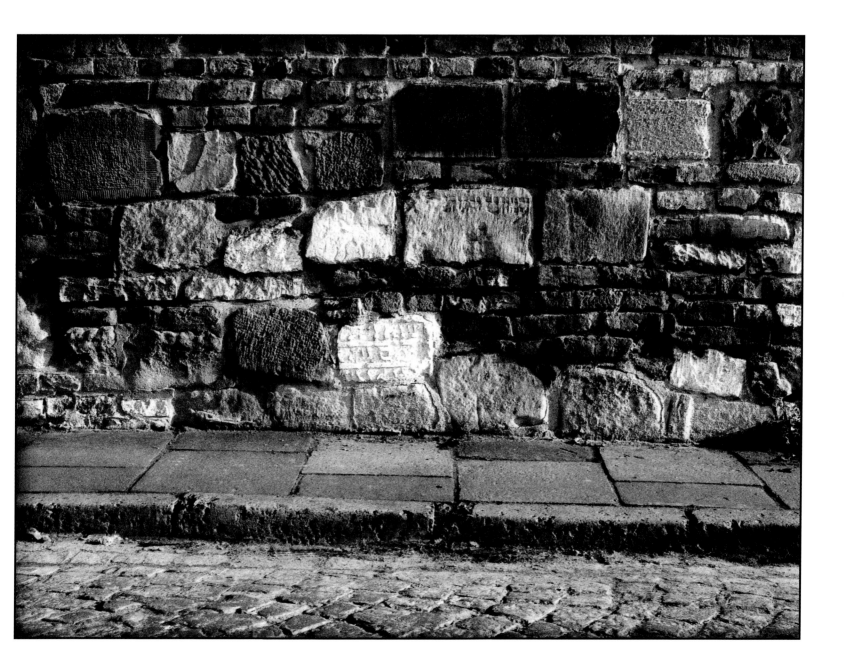

**Nineteenth-Century Synagogue in Use as
Auto Repair Shop,** Olpiny, Poland, 2001

The owner of this auto repair business knows that this building was originally a Jewish synagogue. He said that over the years since the Holocaust it had been used for many purposes. He felt conflicted about investing in needed repairs because, as a former synagogue, he could never acquire the title to the building and become its owner.

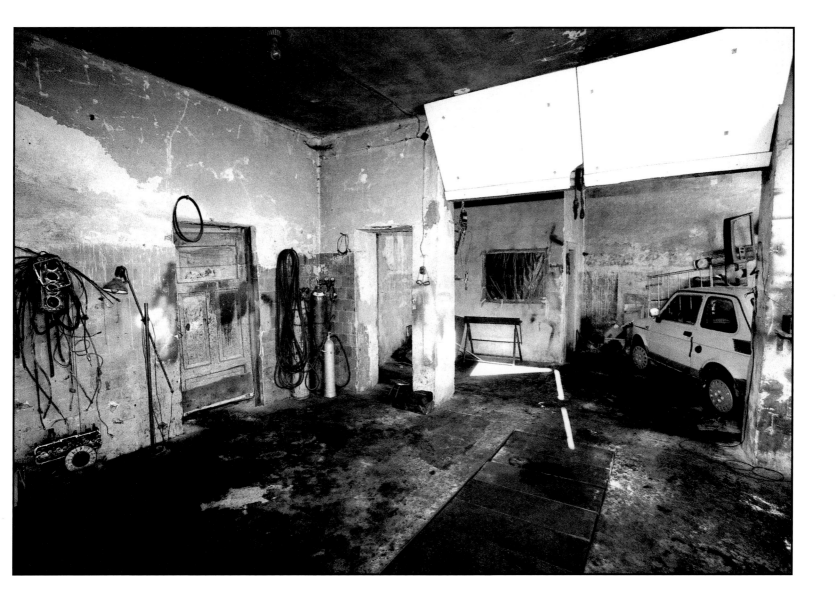

Lublin Corridor #1, Lublin, Poland, 1999

Jews settled here in the fourteenth century. Prior to World War Two, Lublin was home to forty thousand Jews comprising forty percent of the total population. The Majdanek concentration camp is located on the outskirts of Lublin.

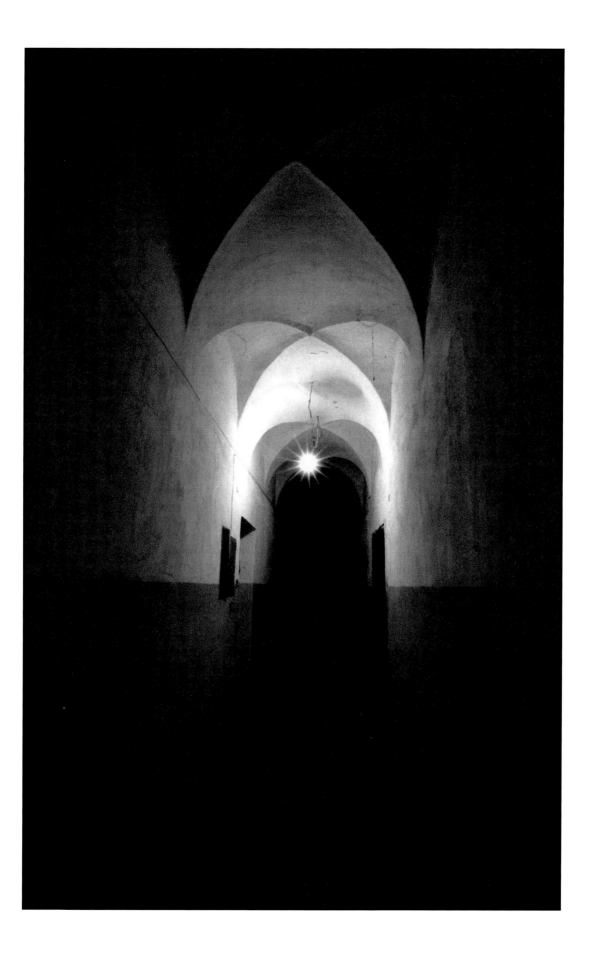

Sidewalk Paved with Jewish Gravestones,
Pinczow, Poland, 1999

This sidewalk is paved with desecrated Jewish gravestones. It is located behind a flour mill whose parking lot is also paved with Jewish gravestones. The Jewish mill owner's home, located nearby, was confiscated by a Nazi officer who used Jewish gravestones to build a staircase to the front door.

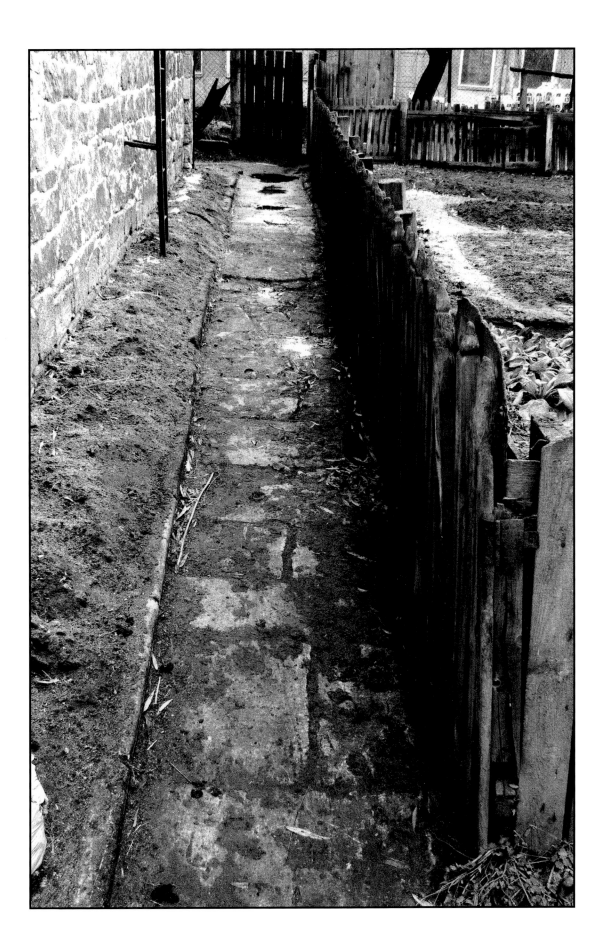

Desecrated Synagogue and Jewish School,
Dzialoszyce, Poland, 1999

Built in 1845, this neoclassical synagogue is now a neighbor-hood trash dump. The roof on the former Jewish school, adjacent to the synagogue, collapsed during the interval between my visits in 1996 and 1999.

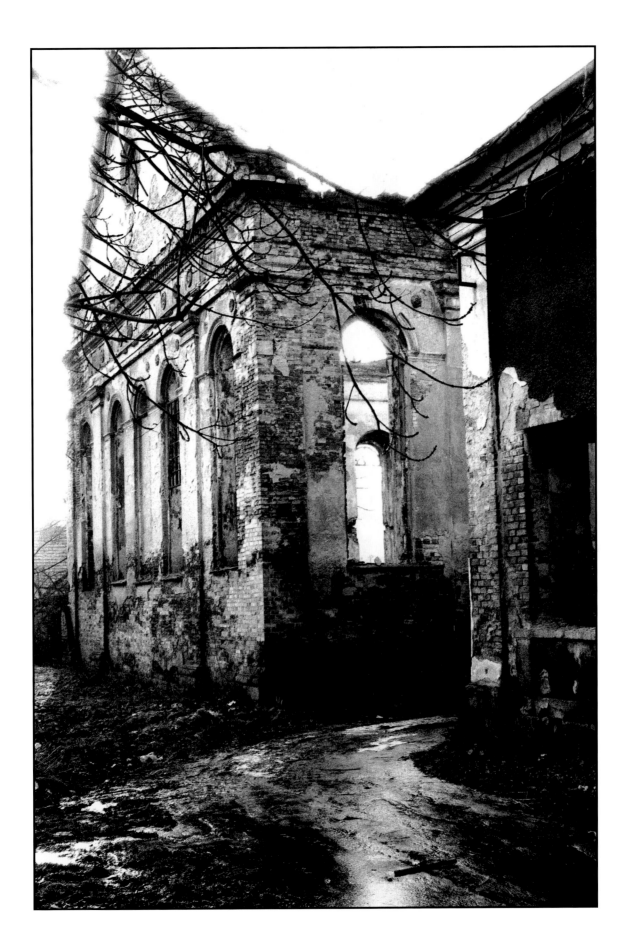

**Last Remaining Segment of Wall around
Wartime Jewish Ghetto,** Cracow, Poland, 1999

This original section of the wall which enclosed the wartime Jewish ghetto in Cracow is where parts of the story narrated in the book *Schindler's List* actually took place. The wall's design was intended to resemble Jewish gravestones. It was constructed by Jewish slave laborers.

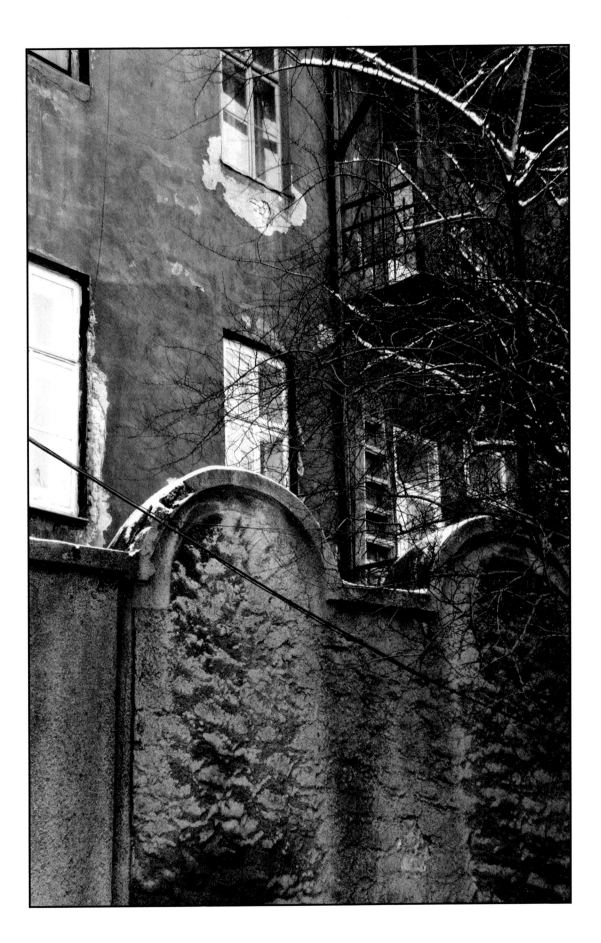

Courtyard in Former Jewish Neighborhood,
Lublin, Poland, 1999

This dwelling in a former urban Jewish neighborhood was once densely populated with poor Jewish families. Rich and poor, educated and non-educated, modern and traditional, secular and religious, the community of Eastern European Jewry before the war was a diverse and thriving cross-section of society.

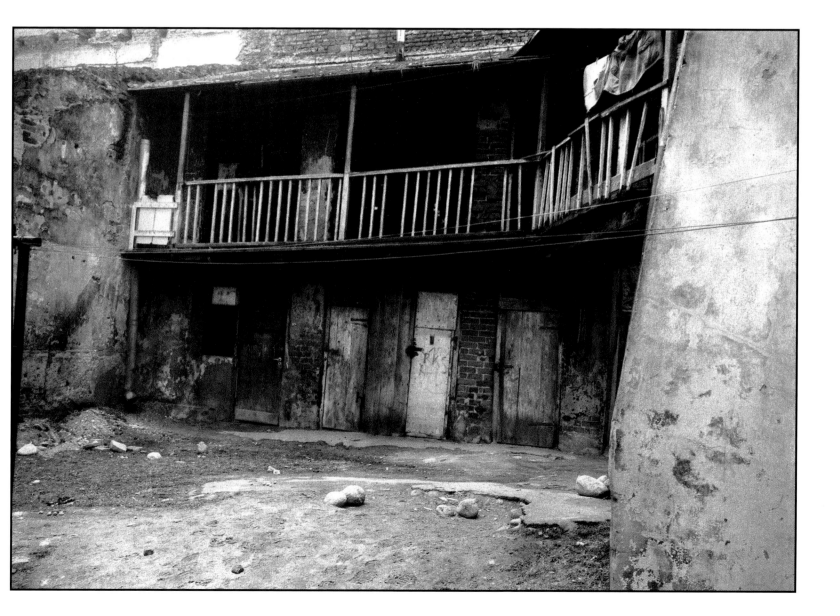

Hay Barn Partially Constructed with Jewish Gravestones, Pinczow, Poland, 2001

The son of the farmer who purchased these Jewish gravestones for use as building material from the Nazis now owns this hay barn. His father bought more gravestones than he needed and a pile of surplus gravestone fragments has been sitting behind this barn for over a half-century.

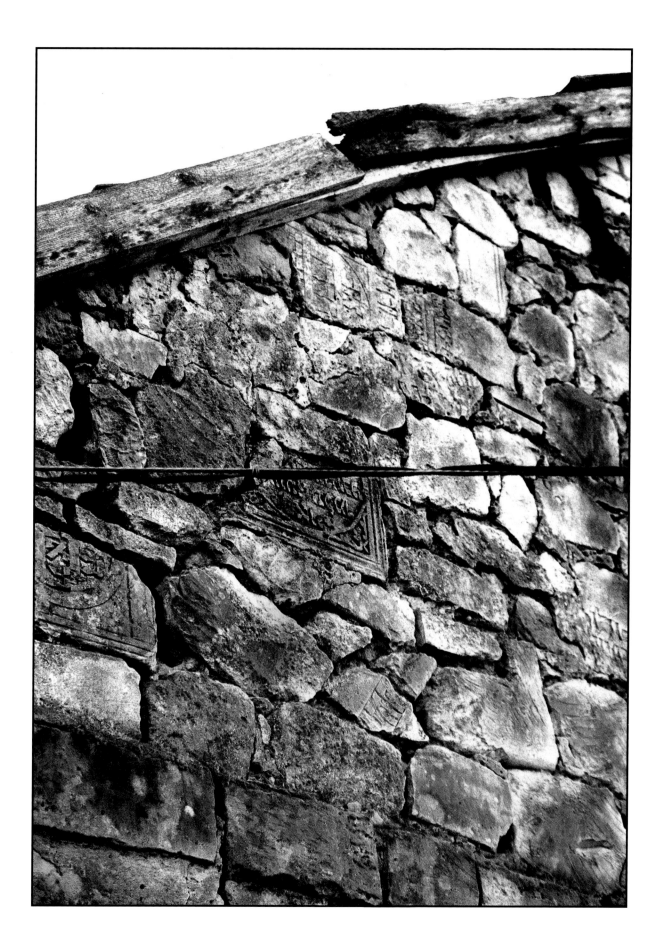

**Jewish Gravestones Cut for Use as
Building Material #2**, Pinczow, Poland, 1999

A Christian with a noble pastime negotiates with area farmers
to allow him to take apart barns made with Jewish grave-
stones. He returns the gravestone fragments to the former
synagogue and builds new barns with his own hands using
standard materials. Numerous barns and garages constructed
with desecrated Jewish gravestones could still be found in
Pinczow when this photograph was taken.

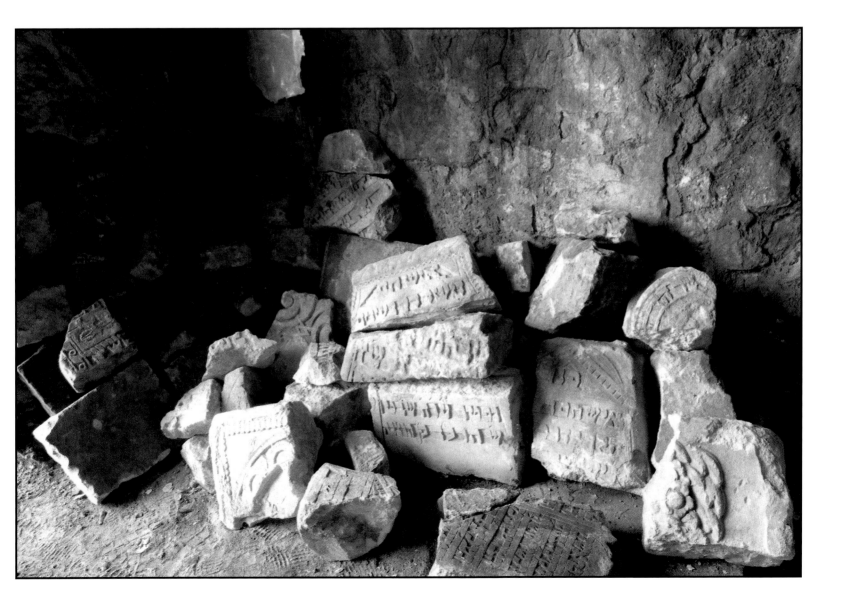

Trauma in Obscurity – A Desecrated Cemetery,
Olkusz, Poland, 1999

Filled with ornately carved gravestones and decorative stone ornamentation, this cemetery has undergone an astonishing degree of destruction. Located at the end of a mud road, it lies a short distance from an American-style pizza parlor and from the busy highway to Cracow.

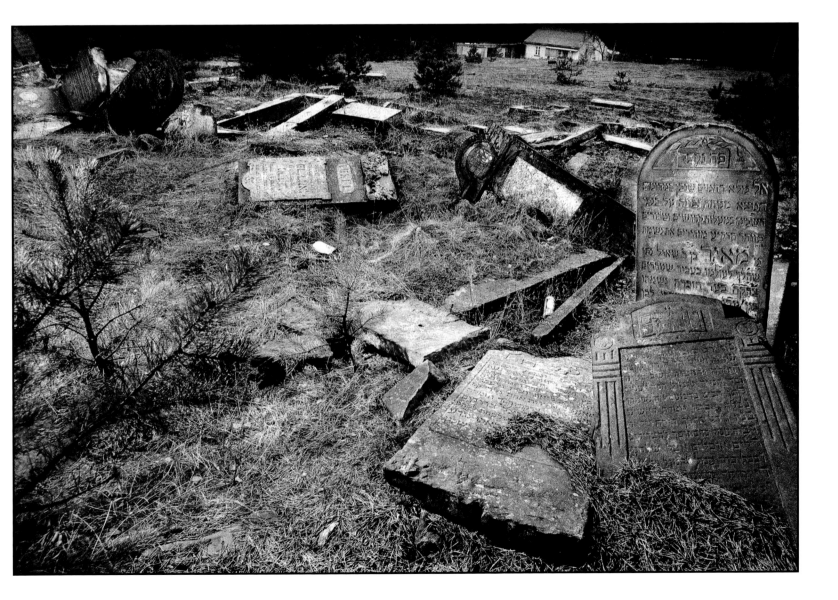

Desecrated Synagogue in Use as Barnyard and Trash Dump, Wodzislaw, Poland, 1999

This structure conveys a quiet grandeur. Built in the seventeenth century, it was converted to a warehouse by the Nazis. When this photograph was taken it was being used as a trash dump and barnyard. The roof had collapsed and the building was falling in upon itself.

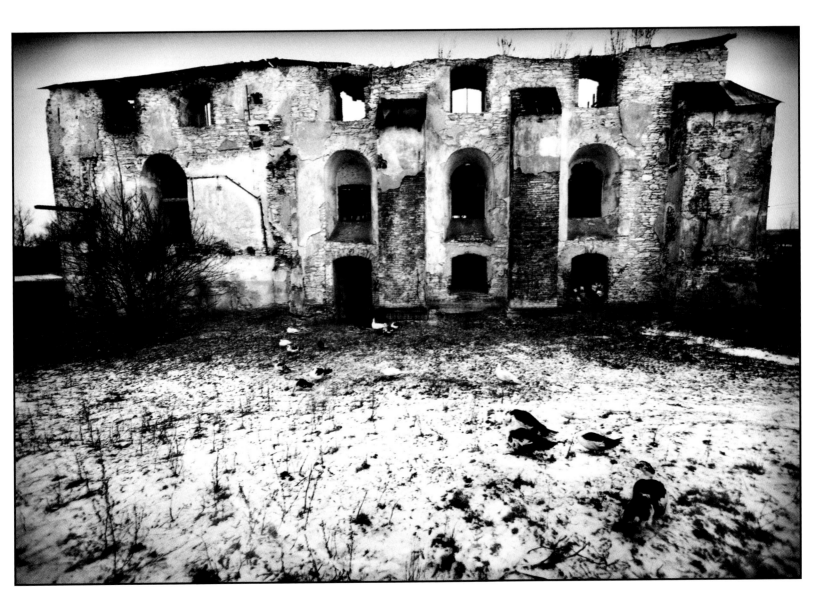

Desecrated Eighteenth-Century Synagogue,
Novy Korczyn, Poland, 2001

The roof on this synagogue, converted by the Nazis to a warehouse, was beginning to collapse when this photograph was taken.

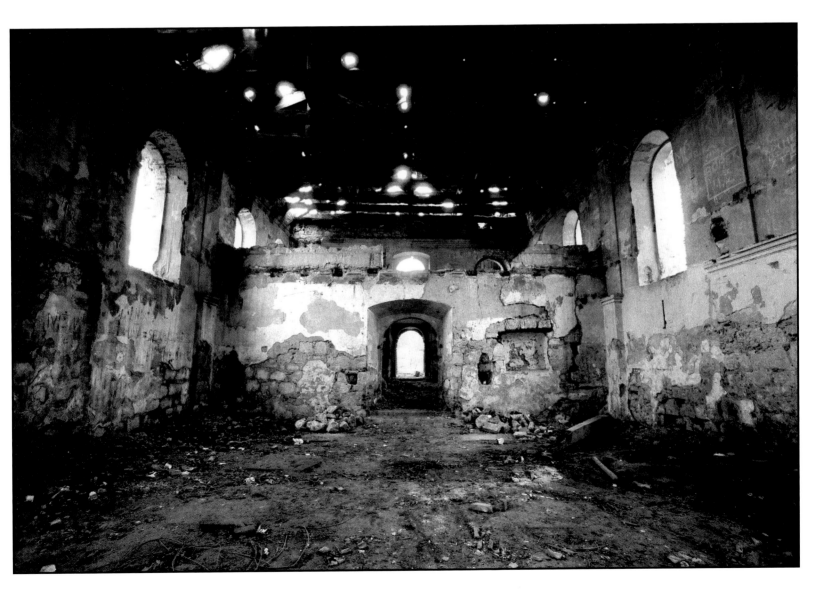

Shattered Synagogue Window,
Dabrowa Tarnowska, Poland, 1999

In June, 1942 the Nazis dragged the Rabbi and his followers from an underground hideout to the Jewish cemetery across the street from this synagogue. As Ruth Ellen Gruber wrote in *Jewish Heritage Travel: A Guide to East-Central Europe*, "Somehow they managed to bring a bottle of vodka with them when the Nazis herded them to the graveyard. In a gesture of both faith and defiance, they toasted each other with the traditional wish *l'chaim* – to life – then joined hands and began to dance. The Nazis shot them down as they were dancing." Many richly colored frescoes remain on the walls of this enormous desecrated synagogue built in the nineteenth century.

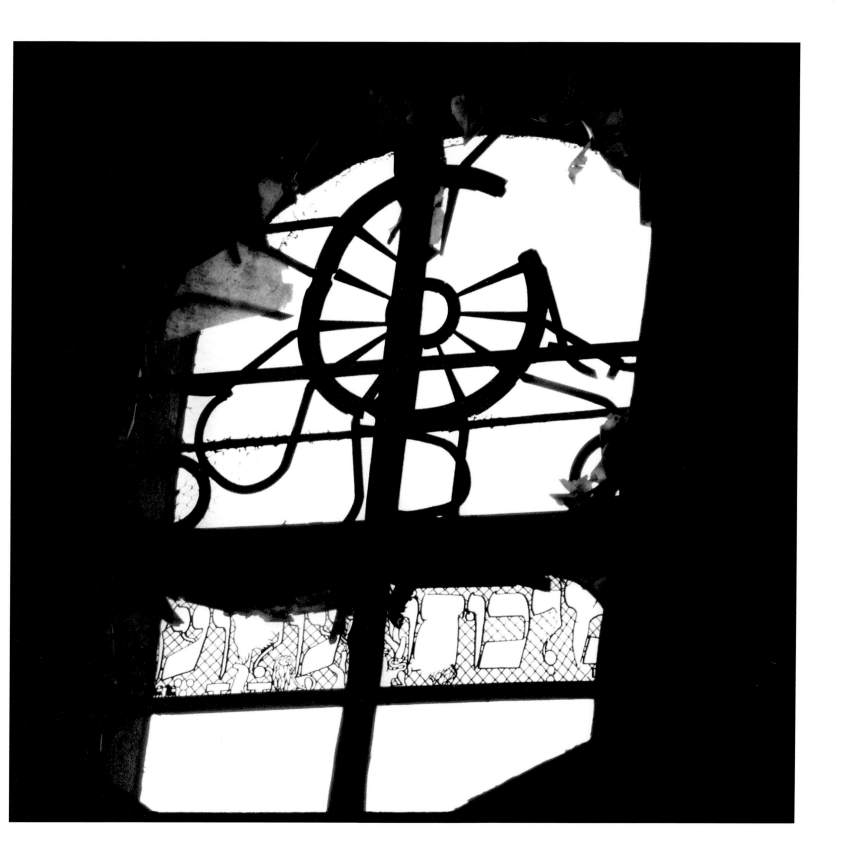

Abandoned Nineteenth-Century Synagogue #2,
Wielkie Oczy, Poland, 2001

Before World War Two thirty-nine Jewish-owned shops and businesses surrounded the small square on which this synagogue is located. The abandoned synagogue remains the most prominent architectural feature of the village.

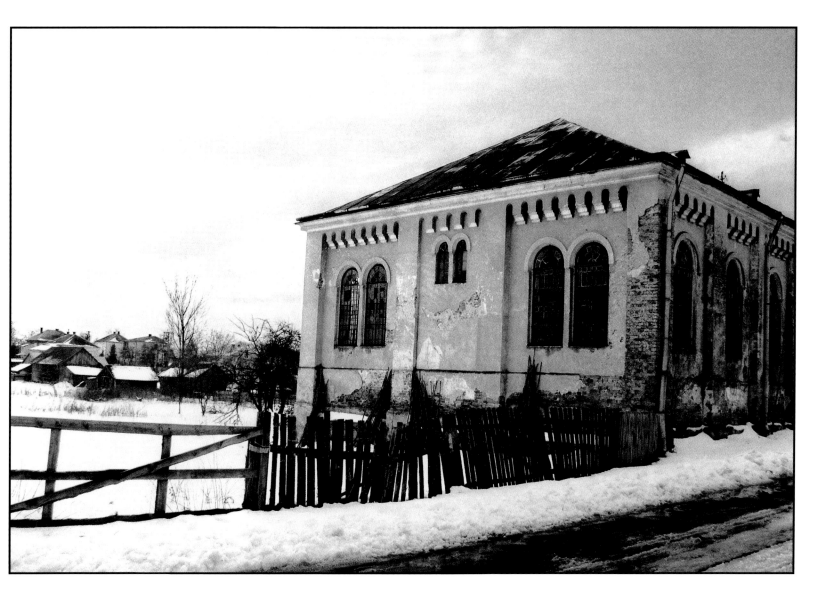

Women's Gallery in Eighteenth-Century Synagogue,
Przysucha, Poland, 1999

This synagogue, located in a small, out-of-the way town, was built in the mid-eighteenth century. Just before the war, nearly seventy percent of the town's 3,200 people were Jewish. This synagogue was also the seat of a Jewish court of law that dispensed justice to the region's Jewish citizens.

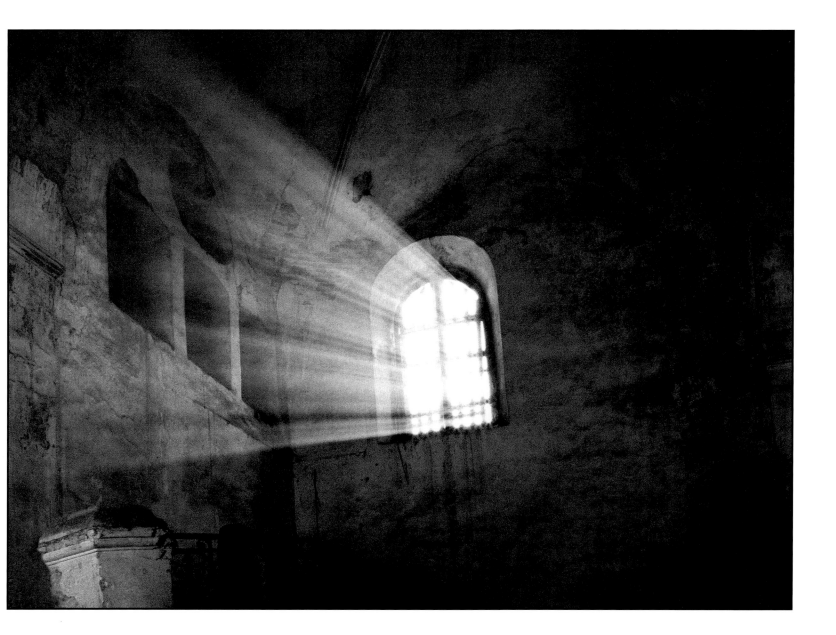

Seventeenth-Century Synagogue Converted by Nazis to Factory Manned by Slave Laborers, Krasnik, Poland, 2001

This synagogue became a sub-camp of the Majdanek concentration camp. Jewish slave laborers toiled inside this synagogue which was converted to a wartime factory by the Nazis.

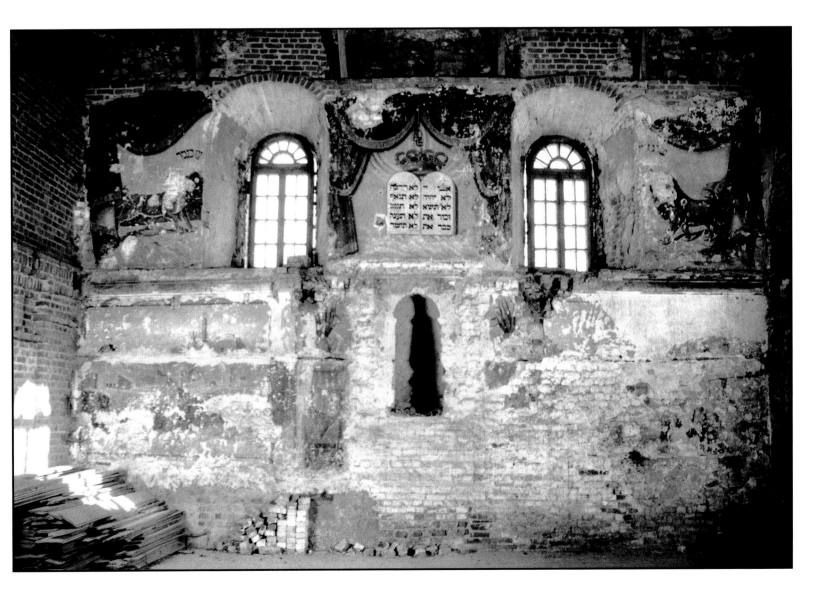

Eighteenth-Century Synagogue Converted by Nazis to Warehouse, Przysucha, Poland, 1999

The Nazis converted this synagogue into a grain warehouse.

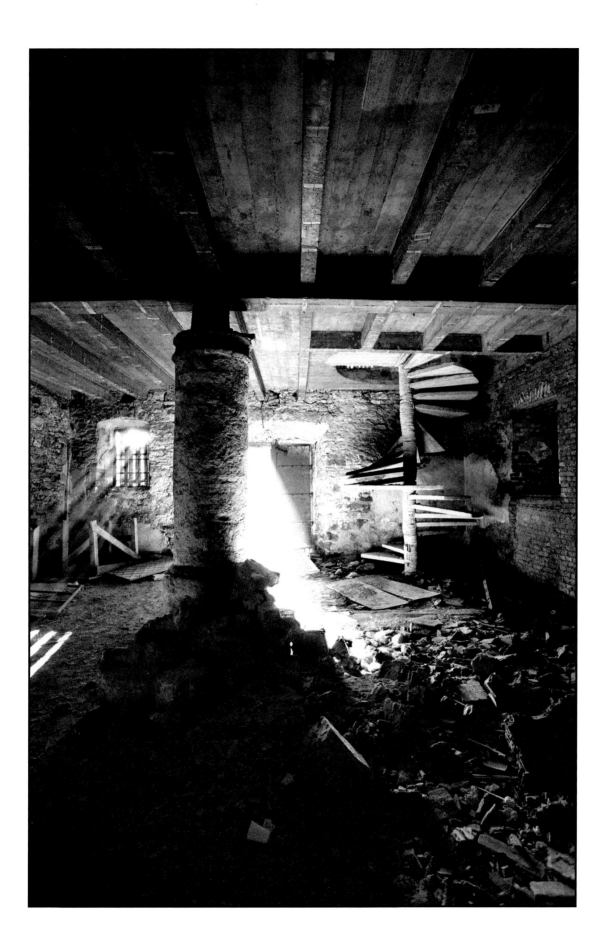

Roofless Splendor – Eighteenth-Century Synagogue, Rymanow, Poland, 1999

"If one ruined synagogue could stand as a memorial to the barbarity of the Holocaust, it could be the tragic ruin in this nondescript village in the southeastern corner of Poland where Jews settled in the fifteenth century," wrote Ruth Ellen Gruber. Multicolored frescoes have survived in this ruin despite over a half-century of exposure to the elements.

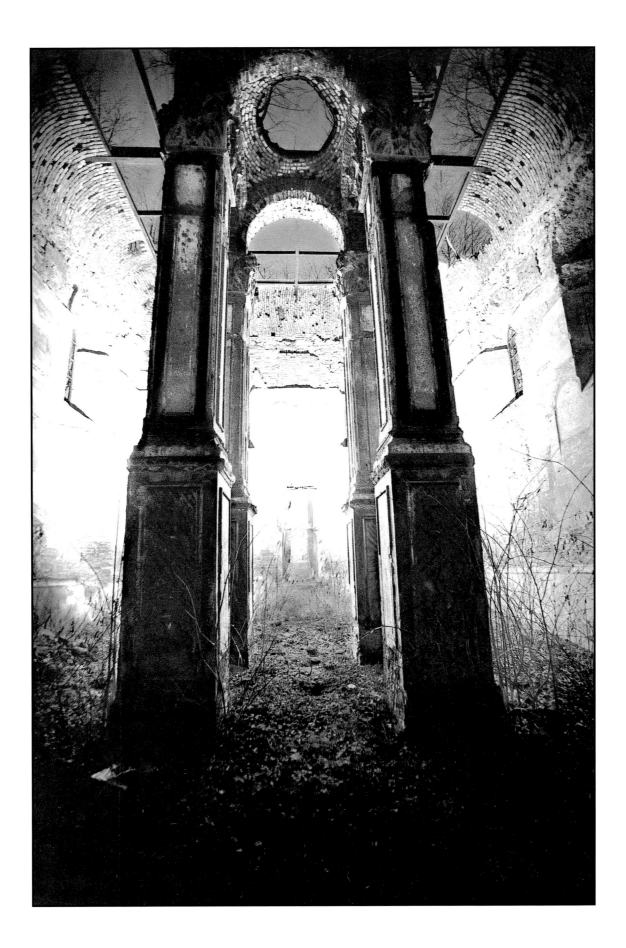

Birkenau Barracks in Winter,
Auschwitz, Poland, 1996

The German forces occupying Poland during World War Two established, on May 27, 1940, a concentration camp on the outskirts of the town Oswiecim. The German name for Oswiecim was Auschwitz, the name also given to the nearby death camp. Over the next few years, Auschwitz was expanded into three main camps: Auschwitz I, Auschwitz II-Birkenau, Auschwitz III-Monowitz, and more than forty lesser camps.

In the words of Raul Hilberg, in *Anatomy of the Auschwitz Death Camp*, "One place has become a symbol for the Jewish catastrophe in Europe: Auschwitz. Its preeminence is rooted in at least three of its many attributes. One is the brute fact of numbers. More Jews died there than in any other locality. Another is geographic. Auschwitz alone was truly continental in scope, drawing its victims from a wide variety of countries and regions. Finally, Auschwitz was also long-standing. After all other death camps had been shut down, it remained in operation – a solitary killing center signifying the will of Nazi Germany to annihilate the Jews in the last hours of a losing war."

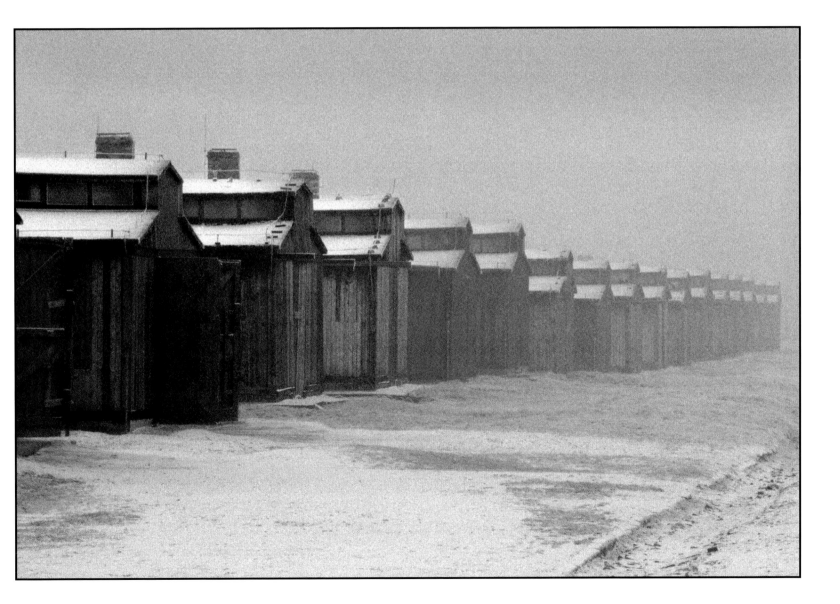

Basement Torture Chamber #2 – Auschwitz,
Auschwitz, Poland, 1996

Inside this torture chamber are several small brick enclosures each about the size of a telephone booth. Prisoners were crammed into these chambers through a small opening at the bottom of the chamber. They stood in complete darkness, without food or water, for days and days.

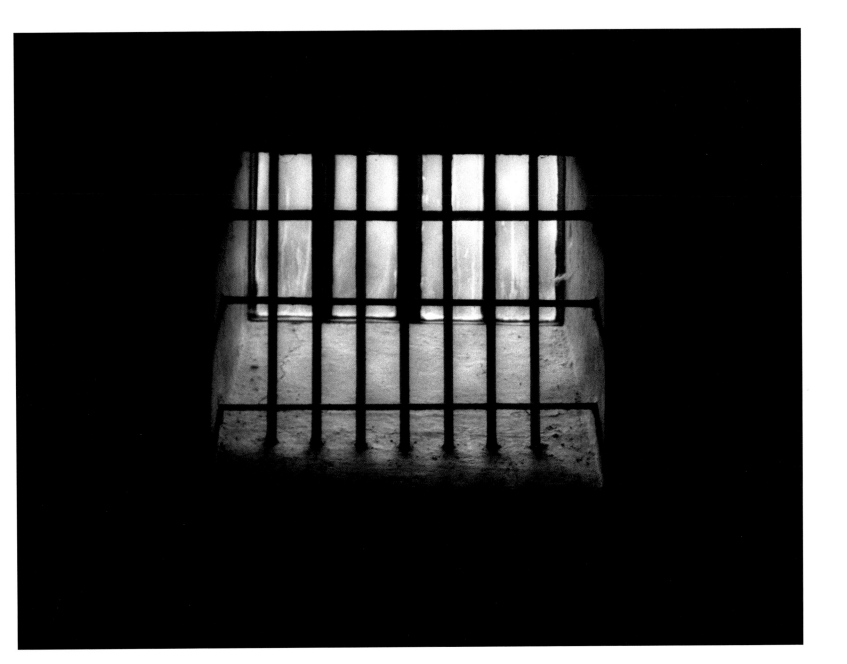

Birkenau in Winter #4,
Auschwitz, Poland, 1996

Cattle cars delivered their human cargo here. "Selections" performed by the Nazis determined who would live and who would die. Many families were separated; mothers, children and the elderly were sent straight to the gas chambers, while the remaining able-bodied individuals were forced into slavery.

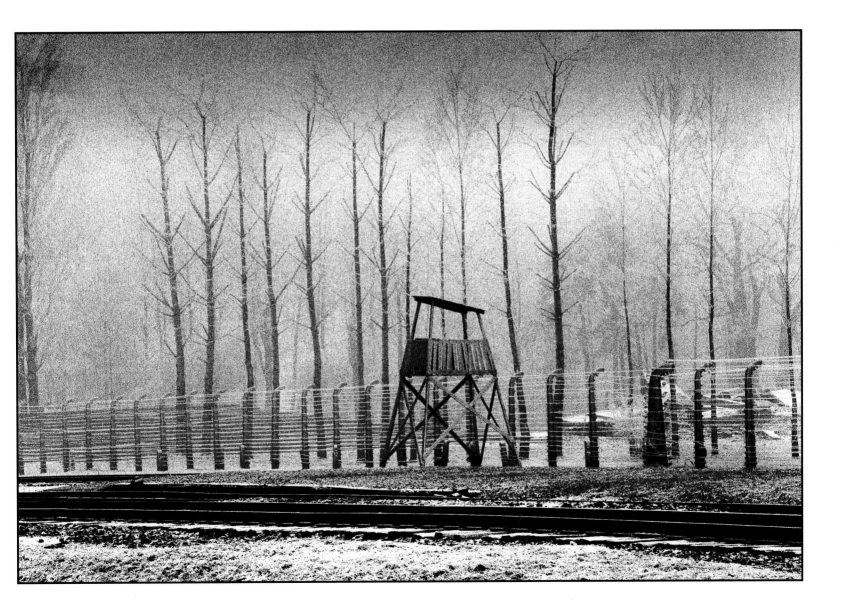

Guard Tower – Majdanek, Lublin, Poland, 1999

This photograph of the concentration camp was taken in dense fog on a quiet, winter morning.

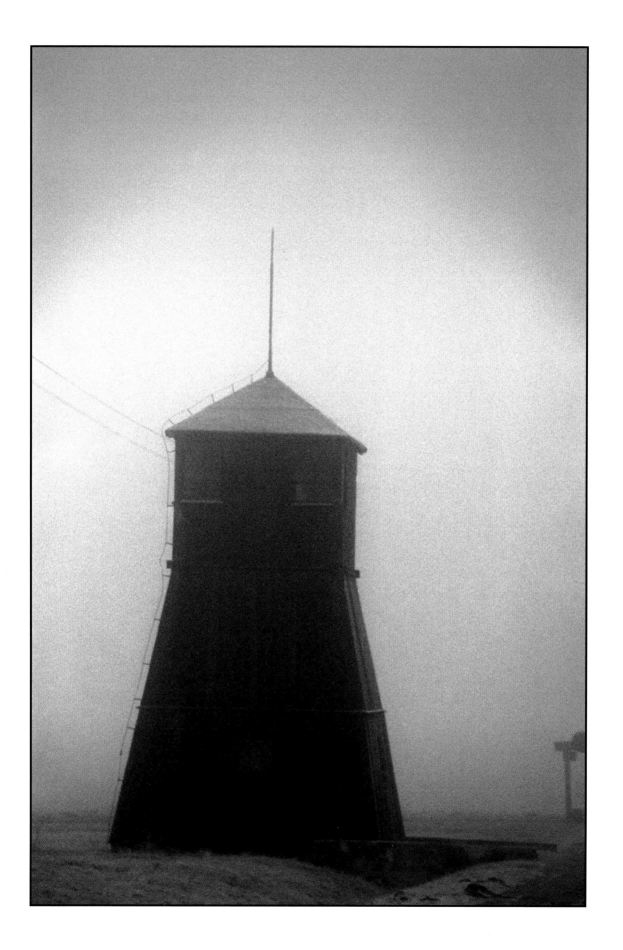

Auschwitz in Winter #1, Auschwitz, Poland, 1996

The words over this gate "Arbeit Macht Frei" are translated as "Labor Liberates."

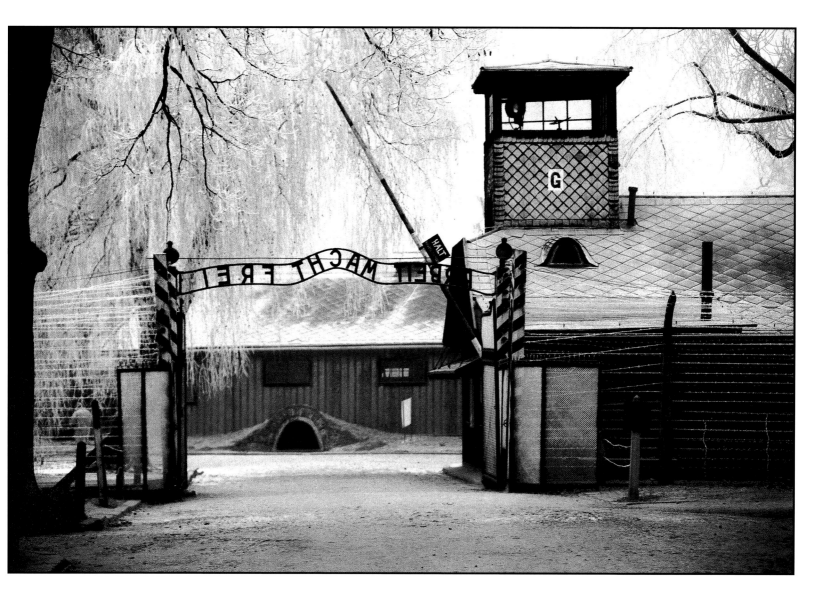

Birkenau Barracks Interior,
Auschwitz, Poland, 1995

Into these uninsulated barracks, originally designed to stable horses, people were packed four persons per hard wooden bed.

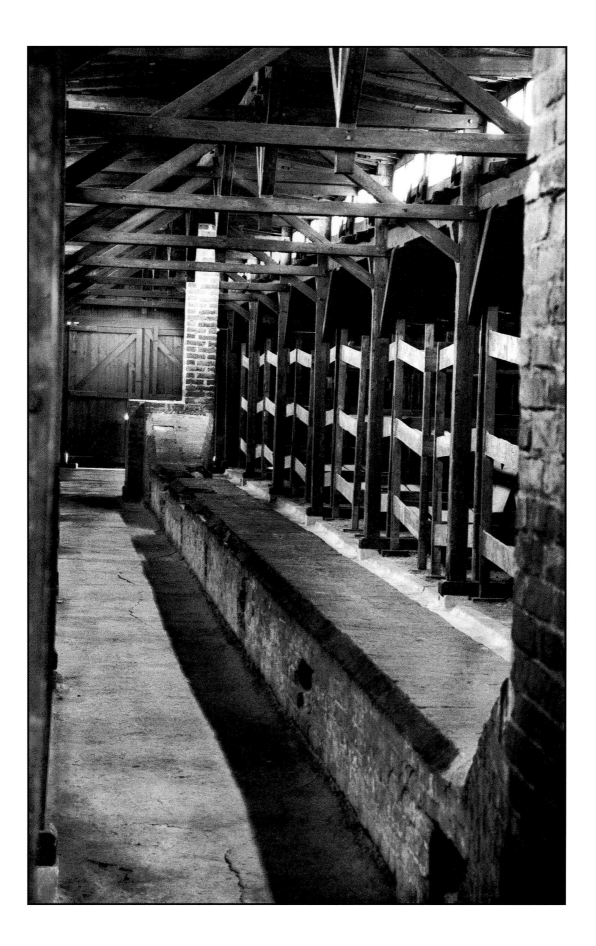

Human Oven – Majdanek, Lublin, Poland, 1999

This is one of a bank of adjacent crematorium ovens that were operated by the Nazis in such death camps as Majdanek.

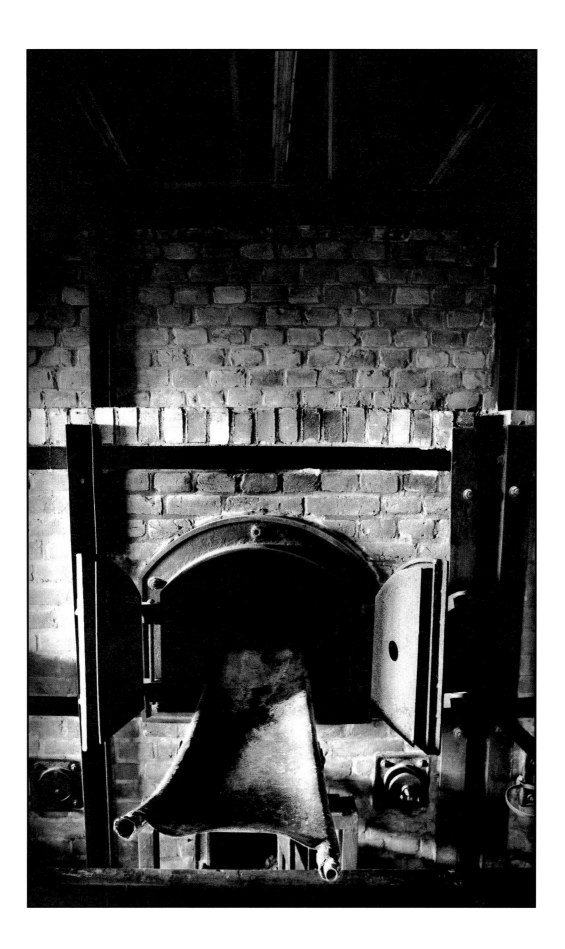

Peephole into Torture Chamber – Auschwitz,
Auschwitz, Poland, 1996

Behind this and adjacent doors, the first experiments with Zyklon B gas were performed in 1941 as a means of carrying out mass murder. Zyklon is a cyanide-based fumigant originally intended to kill rodents.

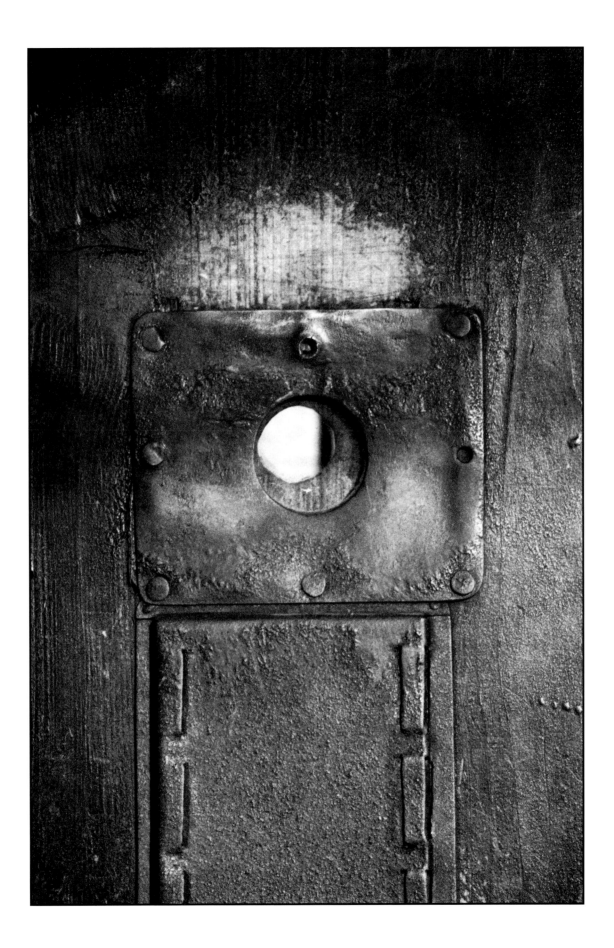

Autopsy Table – Majdanek, Lublin, Poland, 1996

This autopsy table was not used for medical purposes. Murder victims were dissected in search of jewelry either ingested or hidden in body orifices.

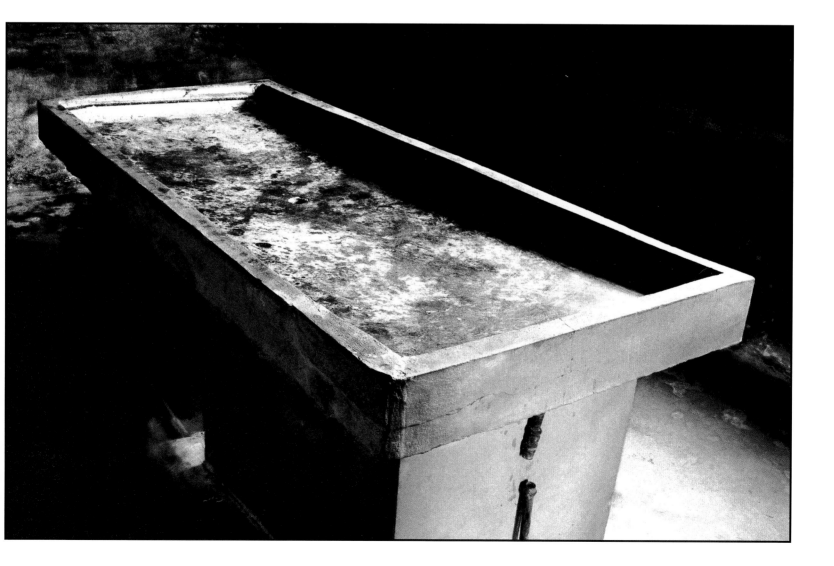

Extermination Ditches – Majdanek,
Lublin, Poland, 1999

This is the site of the Harvest Festival Massacre where nearly twenty thousand Jews were shot on November 3, 1943. The Nazis drowned out the screams of their victims by playing Wagnerian symphonies over truck-mounted loudspeakers. Townspeople lined up to witness this lurid spectacle.

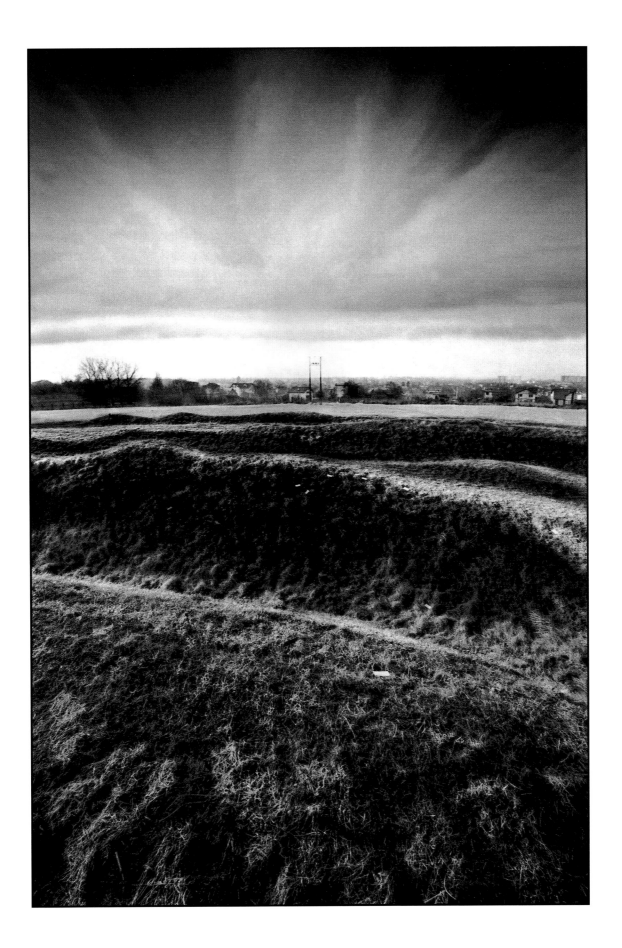

Pond of Ashes – Birkenau, Auschwitz, Poland, 1996

Bones and ashes from the crematorium were ground with large wooden mortars and then dumped into a large pit nearby. Sixty years later, this pit has become a shallow pond.

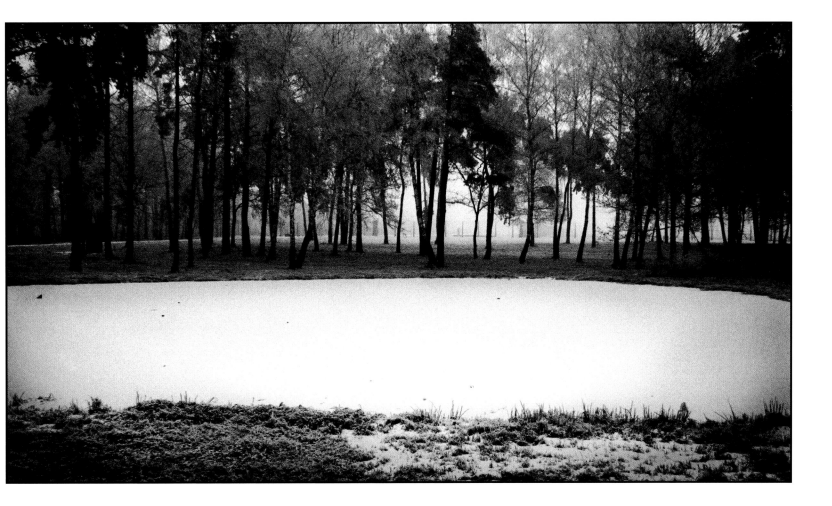

Showers Leading to Gas Chamber – Majdanek, Lublin, Poland, 1999

This is one of the few Nazi gas chamber complexes still intact today.

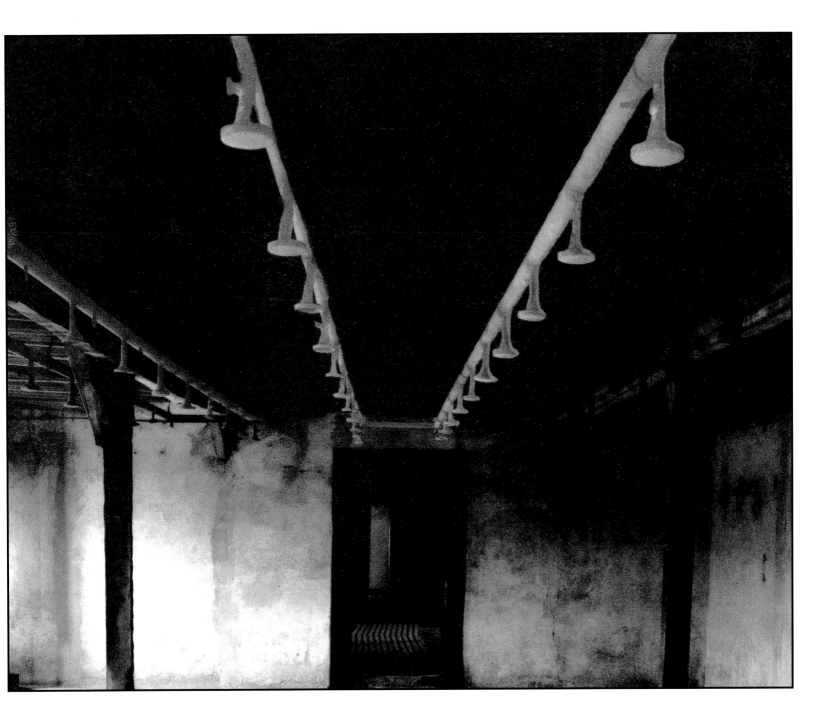

Inside Gas Chamber – Auschwitz,
Auschwitz, Poland, 1996

Zyklon B pellets were dropped through portals in the ceiling of this gas chamber that could hold more than seven hundred people. The solid pellets became lethal cyanide gas once exposed to air at room temperature. Within minutes everyone in the gas chamber was dead. Corpses were carried through the doorway on the right, to the ovens where they were cremated.

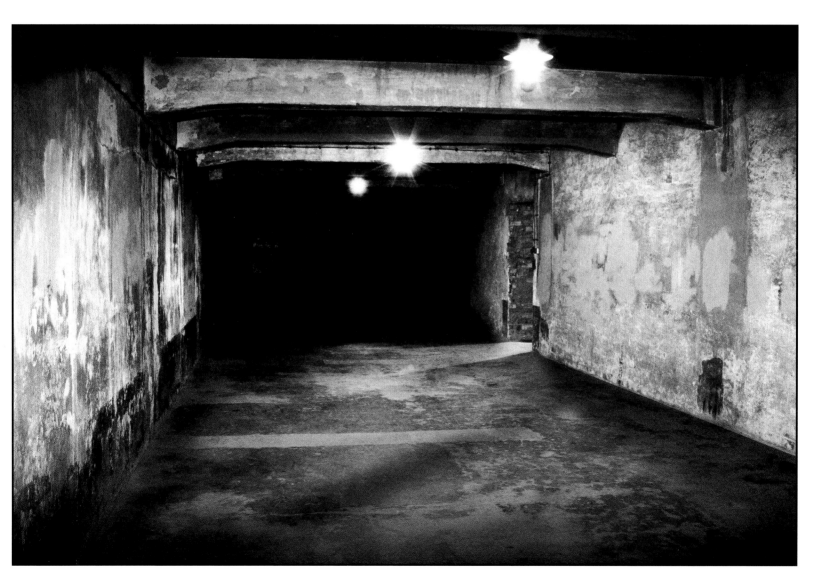

**Large Mound of Human Ashes and Bones –
Majdanek**, Lublin, Poland, 1999

This mound of humas ash and bone is adjacent to the
crematorium. Many intact human bones lie in plain view.

Portable Oven – Majdanek, Lublin, Poland, 1999

The volume of the Nazi's killing exceeded their capacity to dispose of the dead. This portable oven was installed to burn more corpses.

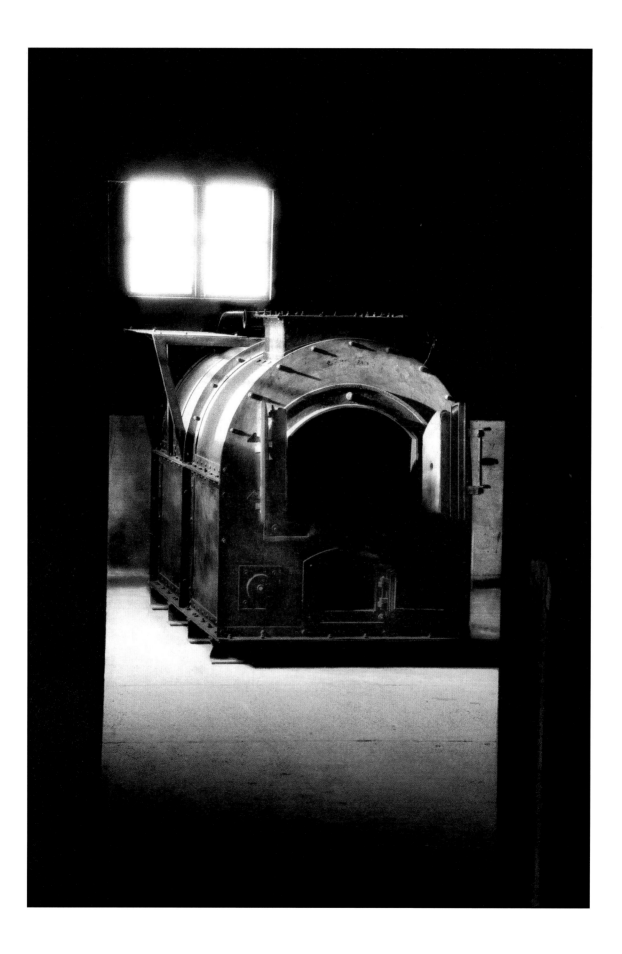

Remnants of Gas Chamber Number Two – Birkenau,
Auschwitz, Poland, 1996

Tens of thousands were sent to their death in this high capacity gas chamber. Within thirty minutes from the time the hermetically sealed door was shut, everyone was dead.

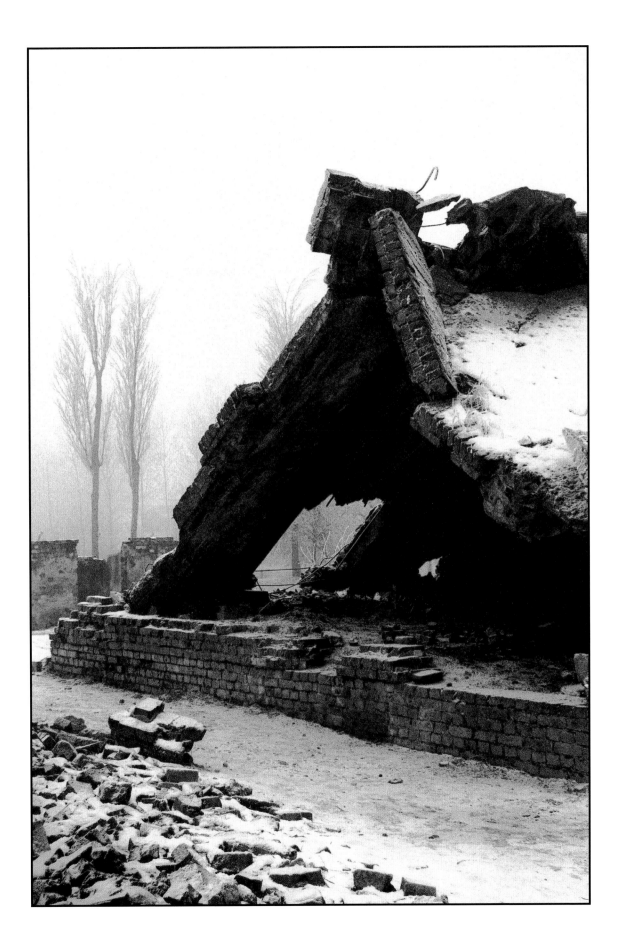

Night Train Passing Rail Station near Belzec,
Belzec, Poland, 2001

Belzec was a death camp where six hundred thousand Jews from throughout Europe were murdered. There are only five known survivors of Belzec. In contrast to Auschwitz, where a portion of arriving Jews were selected to become slave laborers, at Belzec, Jews were taken directly from arriving trains to gas chambers.

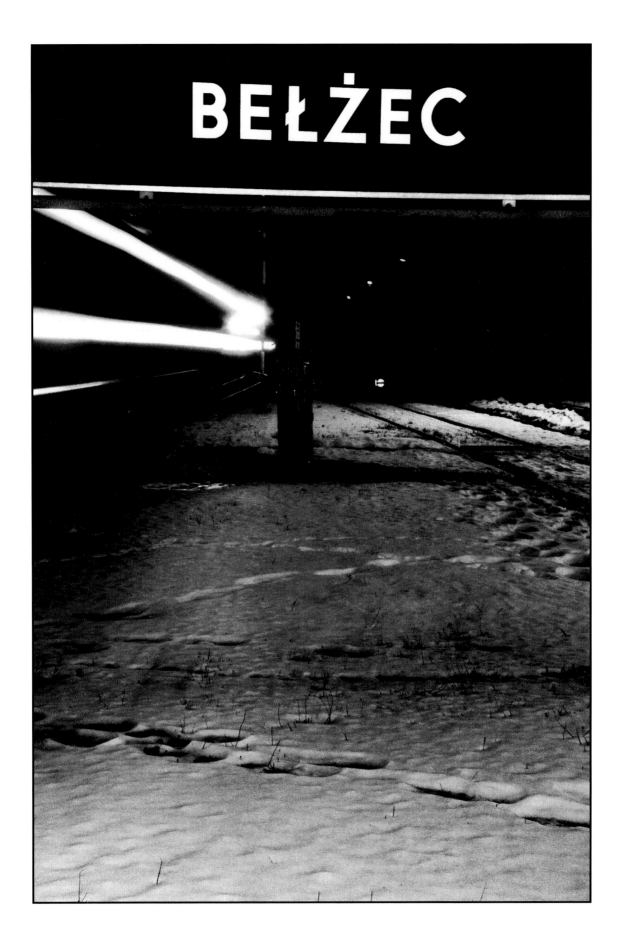

Rear Balcony of Commandant Amon Goeth's Residence – Plaszow Concentration Camp, Cracow, Poland, 2001

In the book *Schindler's List*, the homicidal camp commandant Amon Goeth is depicted shooting Jews, as sport, before breakfast. This is the actual balcony from which he committed these murders. It is the only vantage point amongst this row of former Nazi-occupied homes with a panoramic view of the hillside where prisoners were housed.

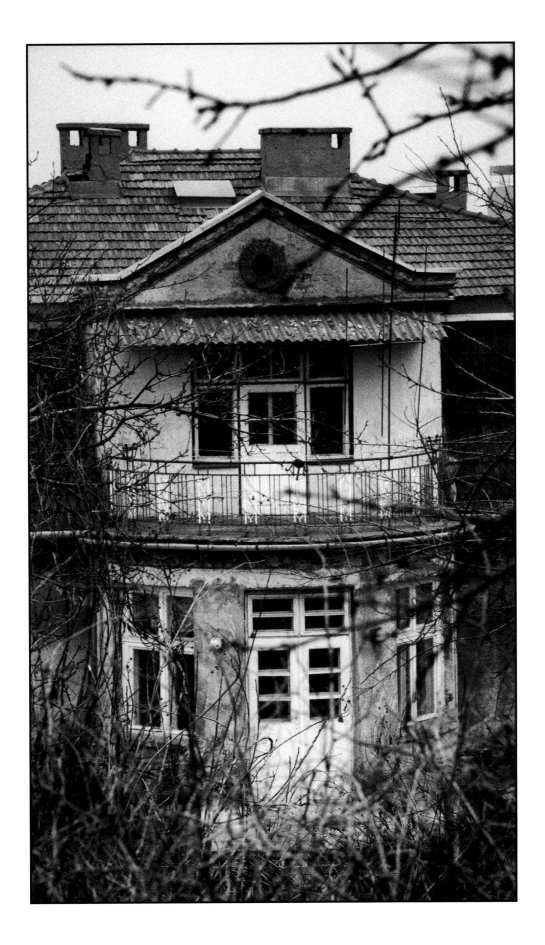

Forest as Sanctuary, Rural Southeast Poland, 1999

For those few who escaped, the dense Polish forests provided shelter. The refugees often lived in underground shelters, moving from place to place.

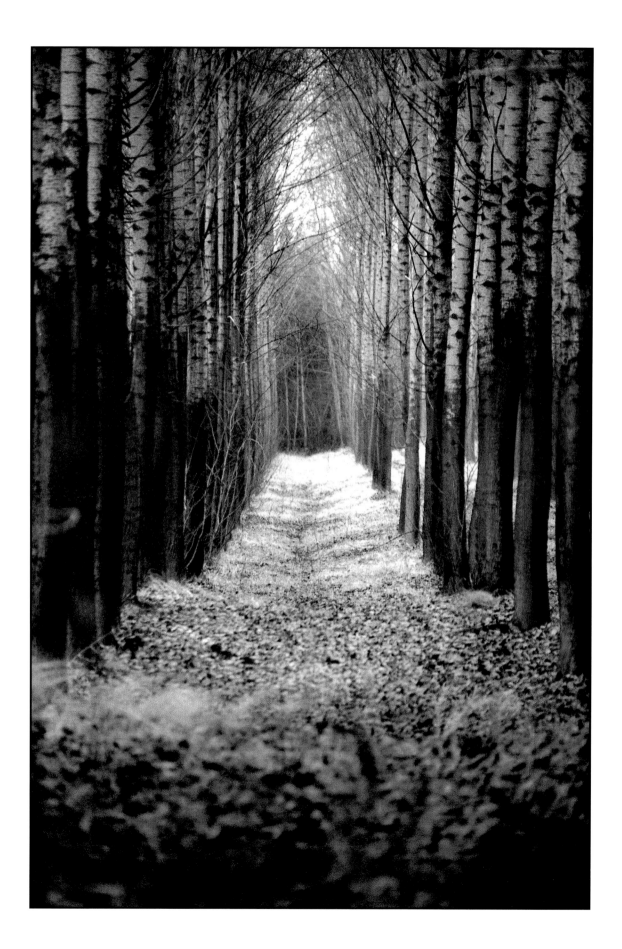

Path of Murder Paved by Nazis with Jewish Gravestones, Krasnik, Poland, 2001

A shop owner who is an avid local historian pointed out this footpath to the Jewish cemetery. Almost ten thousand men, women, and children were marched along here to the cemetery, where they were shot and buried in mass graves. The Nazis paved the path with Jewish gravestones, some of which can be seen seen in this photograph.

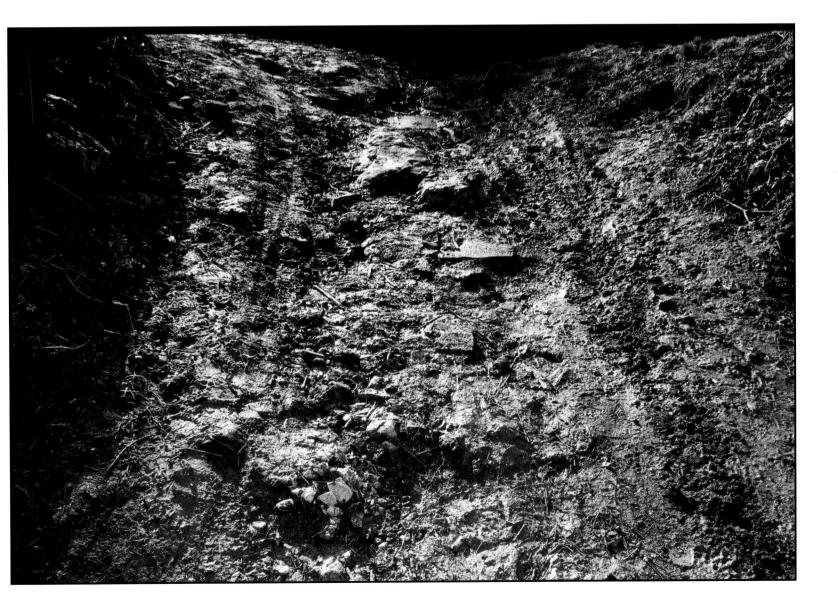

Site of Mass Executions and Mass Grave at the End of the Path of Murder, Krasnik, Poland, 2001

This is the Jewish cemetery where about ten thousand people were murdered and buried in mass graves. Some toppled and desecrated gravestones remain, scattered through the site and under thick brush, but most were stolen by the Nazis and sold as building material.

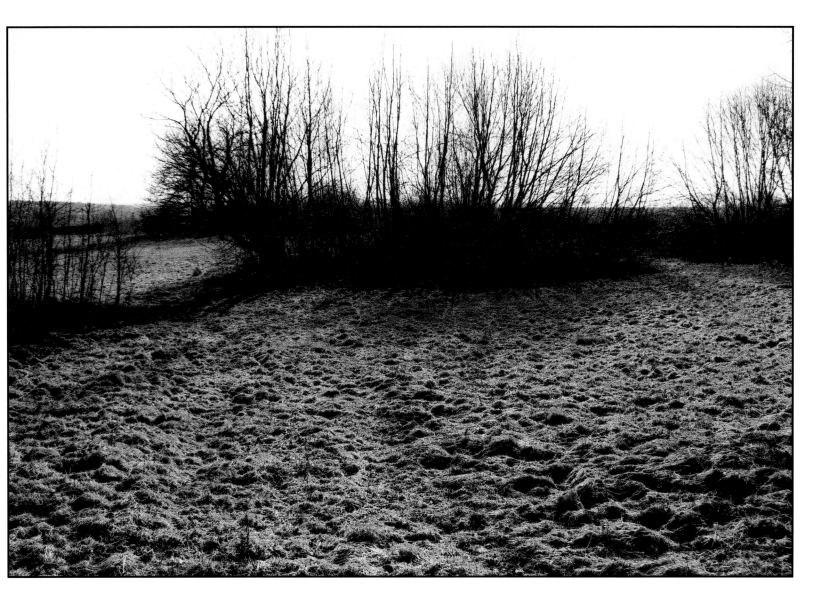

Road to Auschwitz,
Countryside West of Cracow, Poland, 1996

Not everyone taken to Auschwitz went by train. Deportations
by truck traveled this road from Cracow to Auschwitz.

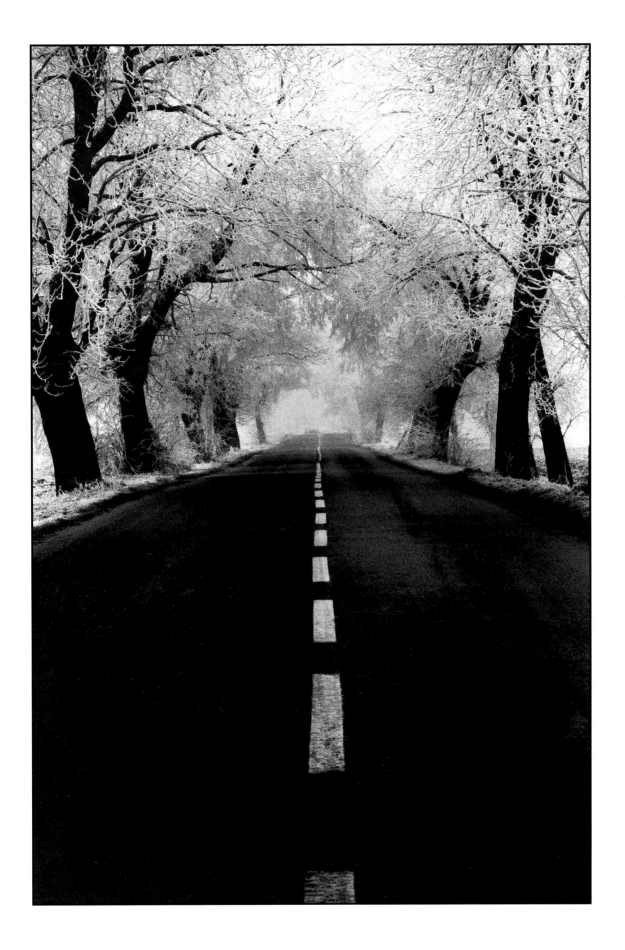

Corridor to the Past #2, Lublin, Poland. 1999

For centuries, the Jews of Lublin walked through this arch, located near the Jewish Gate of this medieval, walled city. Close to forty thousand Jews lived here before the Holocaust. The Nazis razed the centuries-old Jewish quarter.

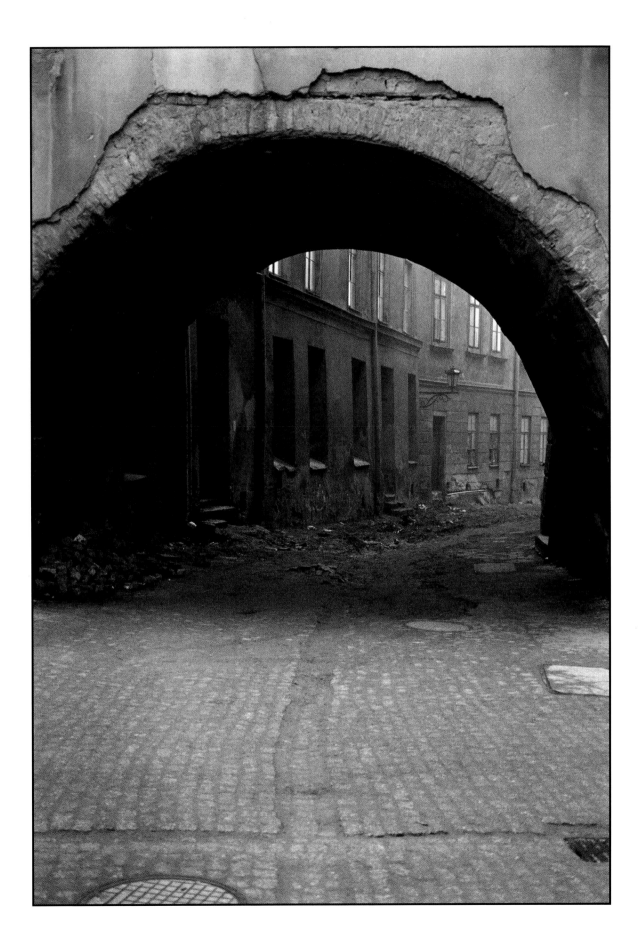

Former Jewish Home in Use as Public Toilet,
Dzialoszyce, Poland, 1996

The indentation on the right side of the doorframe is where the mezuzah was once affixed. A mezuzah is a small parchment scroll on which two paragraphs from the Torah are inscribed and encased in metal or wood. The spray-painted letters "WC" designate that a public toilet was located behind these ornate doors.

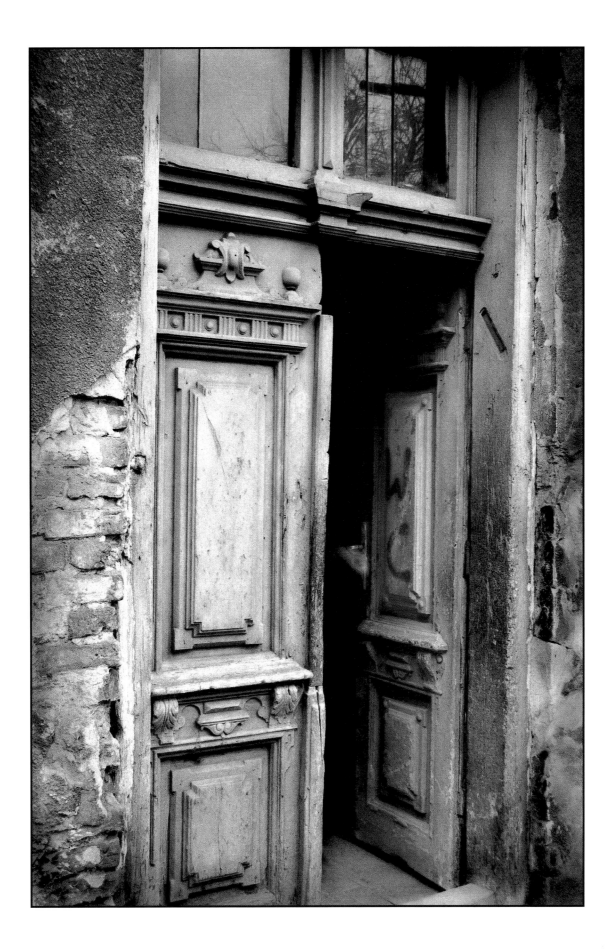

Where They Lived #4, Cracow, Poland, 2001

This apartment building is located in the heart of the former Jewish quarter of Cracow.

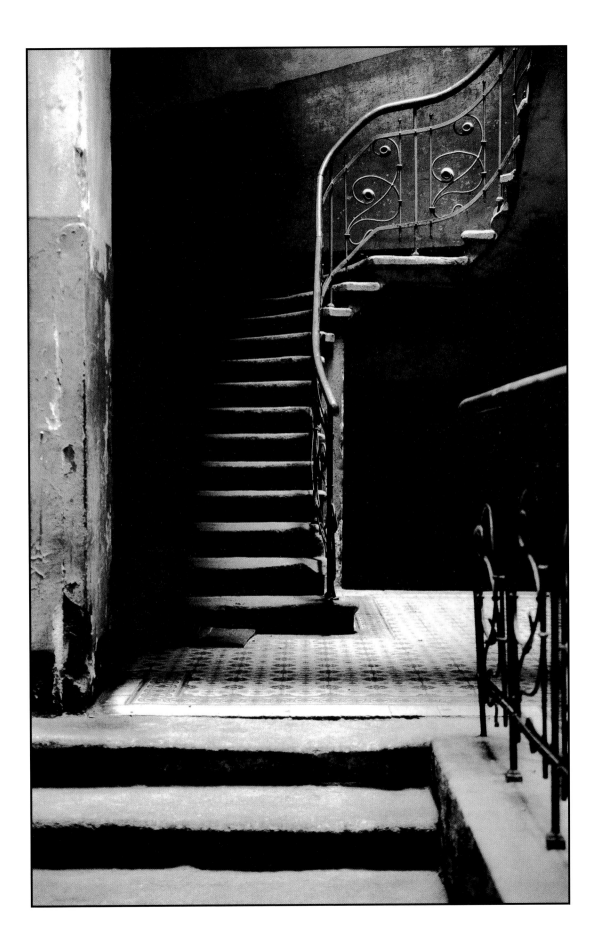

Sealed Entry to Desecrated Nineteenth-Century Synagogue, Dabrowa Tarnowska, Poland, 1999

This large synagogue is now empty and in a state of disrepair.

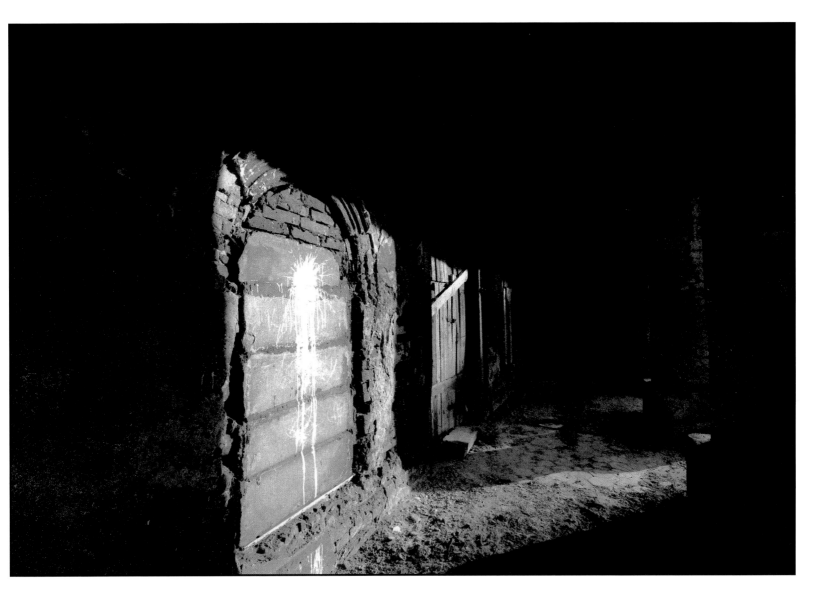

New Home Construction on the Grounds of Jewish Cemetery, Chmielnik, Poland, 1999

In the background of this photograph can be seen the town's large, now-abandoned synagogue, originally built in the 1630s. The Nazis converted it into a warehouse. These newly constructed homes lie inside the perimeter wall of the Jewish cemetery. The Nazis ripped up the gravestones and sold them as building material.

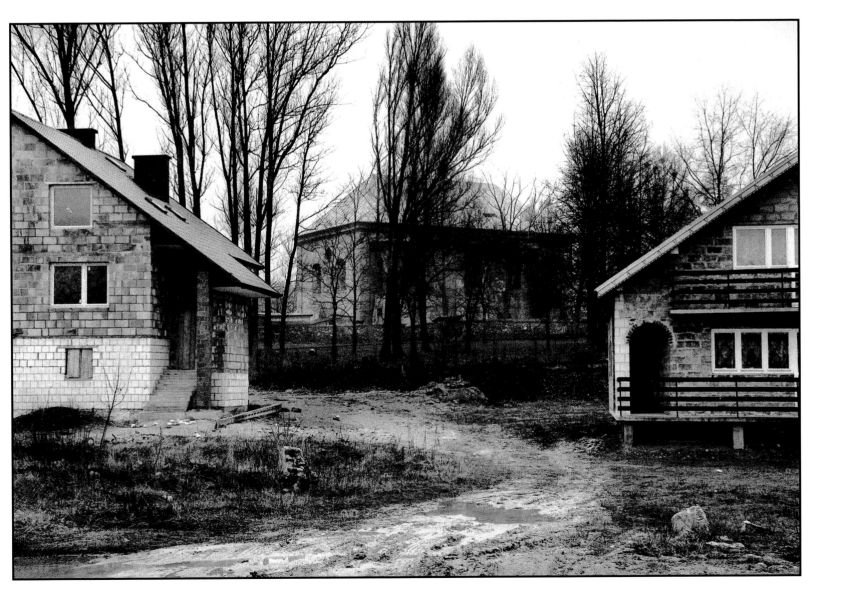

Fifteenth-Century Synagogue, Cracow, Poland, 2001

Roman Vishniac photographed this same spot just before the Holocaust. His image captures the vibrant community life that once existed here: Jews milling about with umbrellas in hand on a snowy winter day.

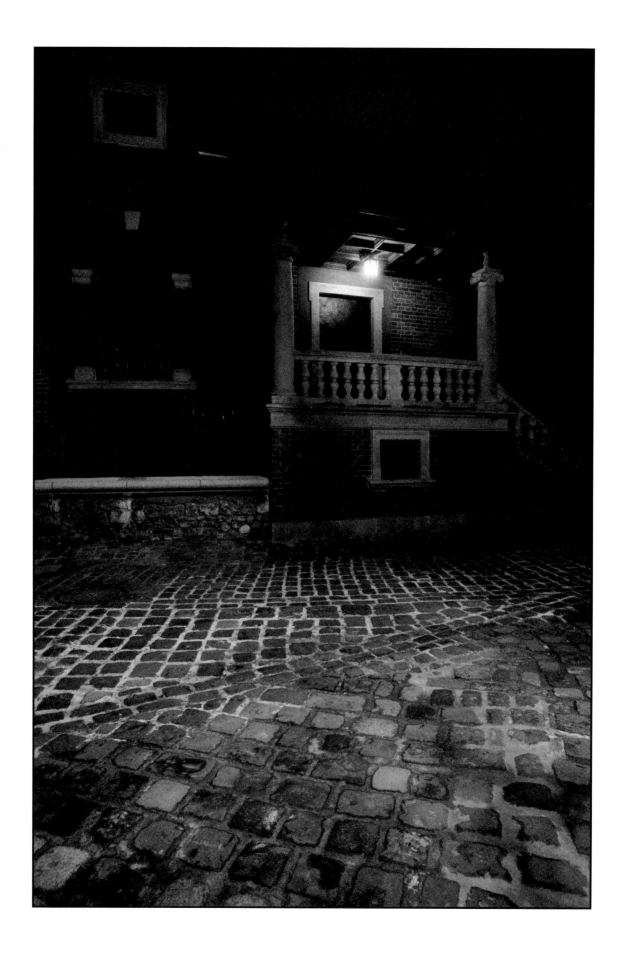

Eighteenth-Century Synagogue Converted by Nazis to Grain Warehouse, Przysucha, Poland, 1999

Steel doors have replaced the ornate wooden doors that now lie in the dirt.

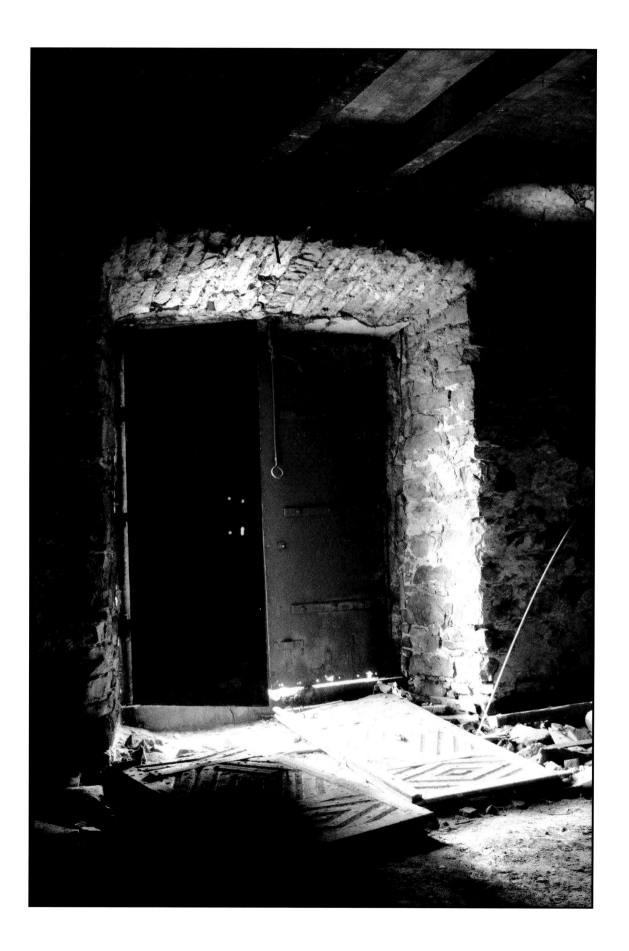

Multicolored Fresco of Lion in Roofless Seventeenth-Century Synagogue, Rymanow, Poland, 1999

The inscription on the left-hand side reads, in part, "Resh Lakish said, Whoever has a synagogue in his town and does not go there in order to pray is called an 'evil neighbor' as it is said, (Jeremiah 12)." According to the Talmud, Resh Lakish was a gladiator who put down his weapons and took up Torah. He lived during the time of the destruction of the Second Temple.

The right hand side of the photo reads, in part, "Yehudah ben Tema said, 'Be bold as a leopard, light as an eagle, swift as a deer and strong as a lion, to carry out the will of your Father in heaven.'"

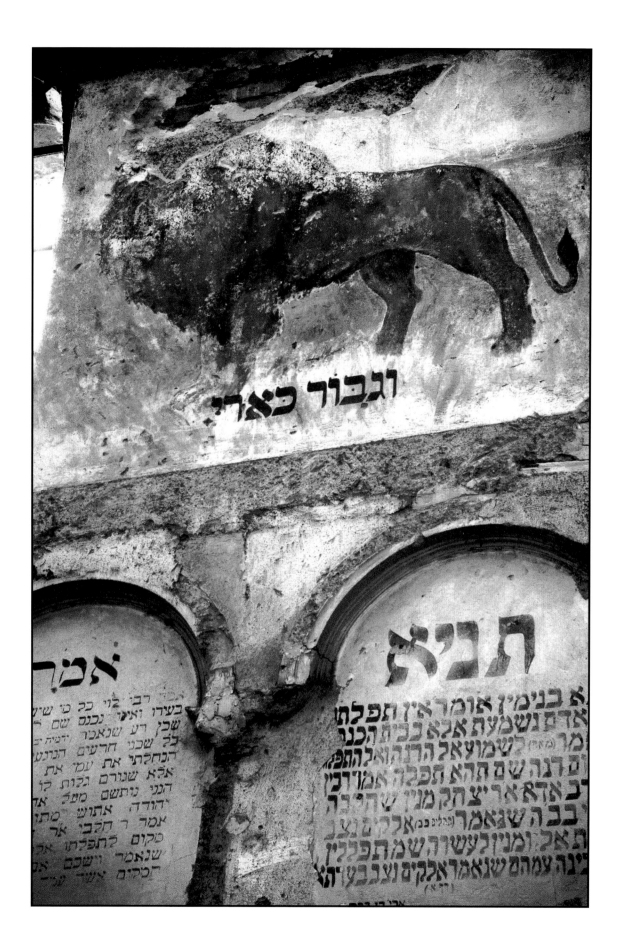

Desecrated Synagogue, Grybow, Poland, 2001

An elderly woman who lives across the street from this synagogue said that before his murder, the Rabbi secretly gave the synagogue's Torah to the Catholic priest at the church located down the street for safekeeping. She said that the Torah remains in the church to this day.

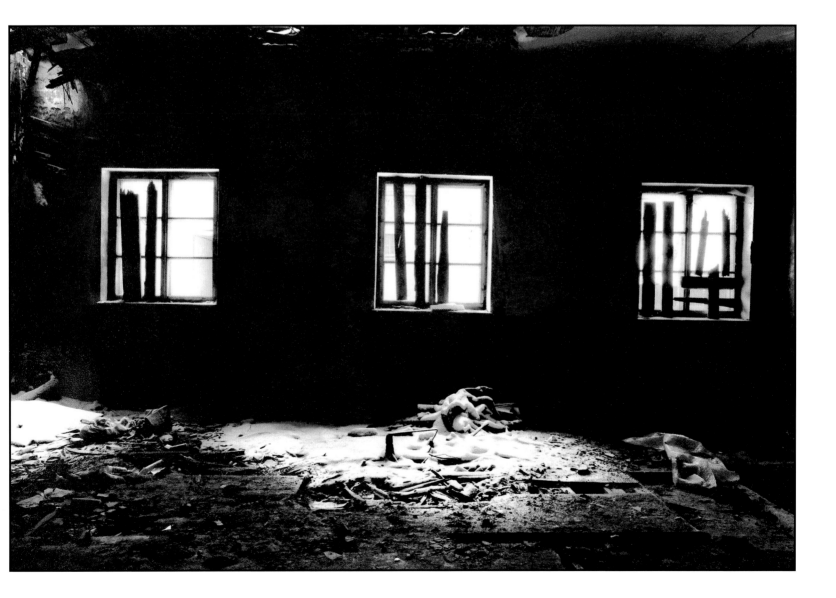

Severely Defaced Synagogue Interior,
Novy Korczyn, Poland, 2001

The detail around the Torah niche in this synagogue can be seen in contrast to the defacement and graffiti on the interior walls.

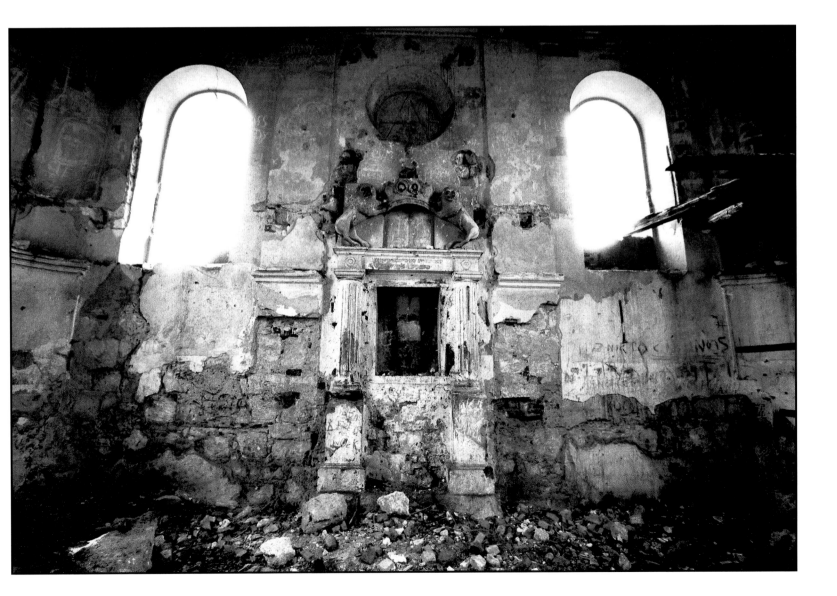

Alone in Perpetuity, Krzepice, Poland, 2001

Krzepice is a small rural town inhabited for centuries by Jews. Only one side of this metal grave marker, meant to mark the graves of a married couple, has been inscribed.

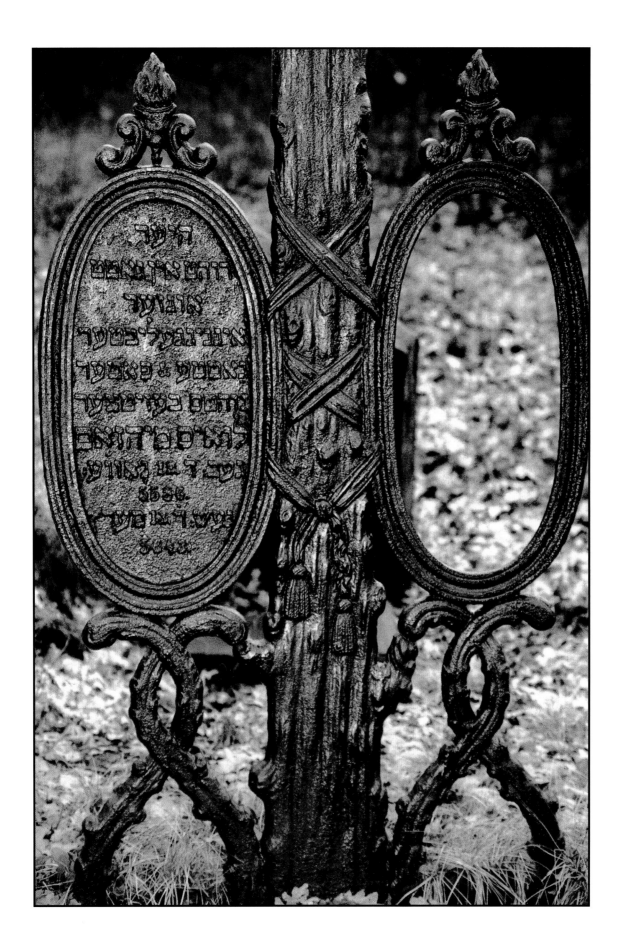

Abandoned Jewish Cemetery, Ryglice, Poland, 2001

This unmarked cemetery is located on the outskirts of Ryglice.

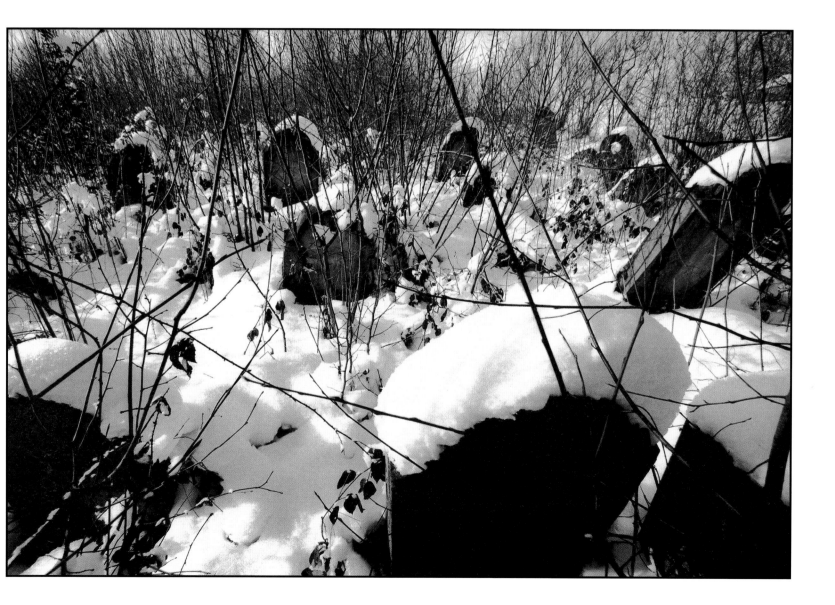

Shower Head in Gas Chamber Complex – Majdanek,
Lublin, Poland, 2001

A shower head in one of the gas chambers.

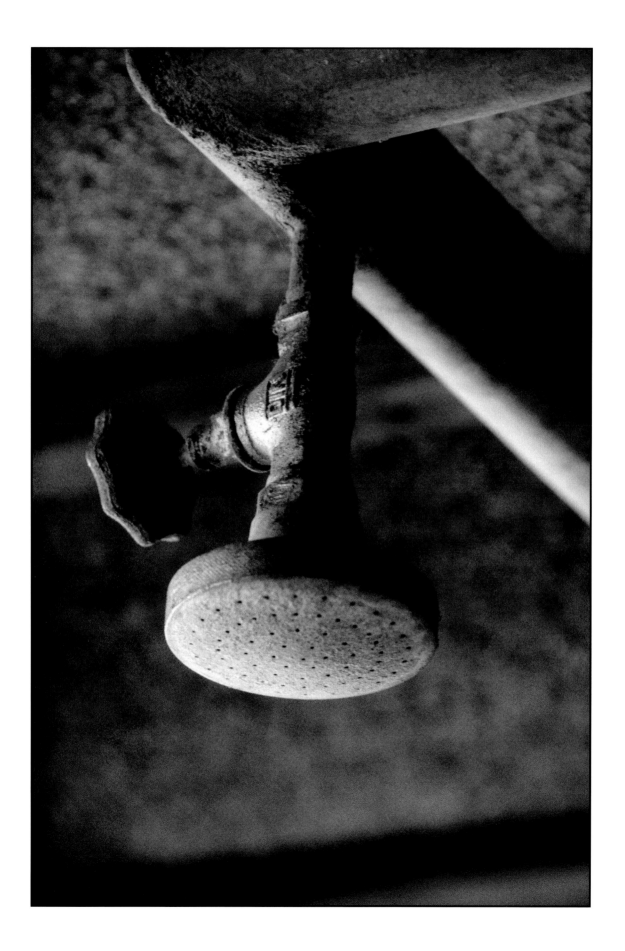

Bifurcation Leading to Unloading Platform – Birkenau, Auschwitz, Poland, 2001

This split in the tracks allowed for multiple trains with their human cargo to be unloaded simultaneously. The Nazis at Birkenau executed nearly eight thousand people per day.

Birkenau in Winter #7, Auschwitz, Poland, 1996

The sheer size of the Birkenau addition to Auschwitz is only suggested here.

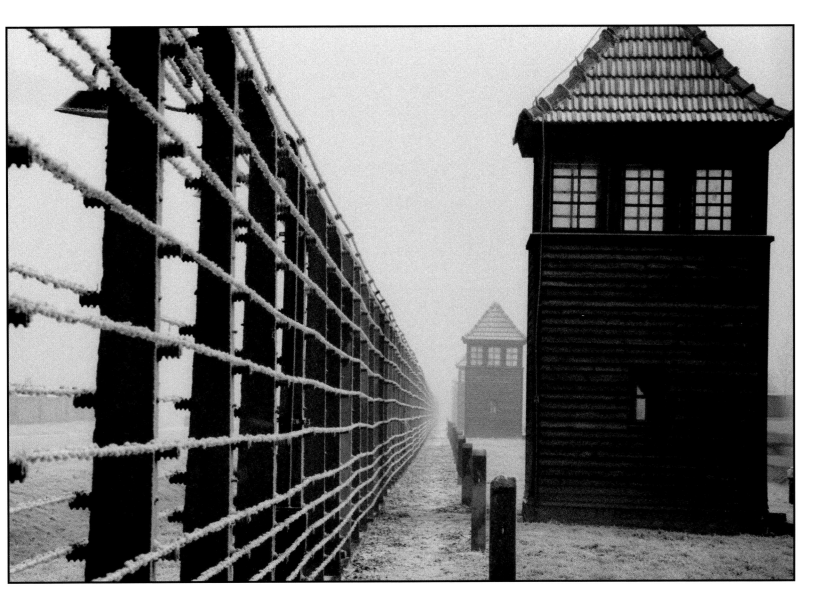

Hilltop Cemetery, Bobowa, Poland, 1996

Located in a hilly region of Poland and surrounded by plowed farm fields, this pastoral setting was the site of a mass murder. A mass grave is situated close to the cemetery's entrance.

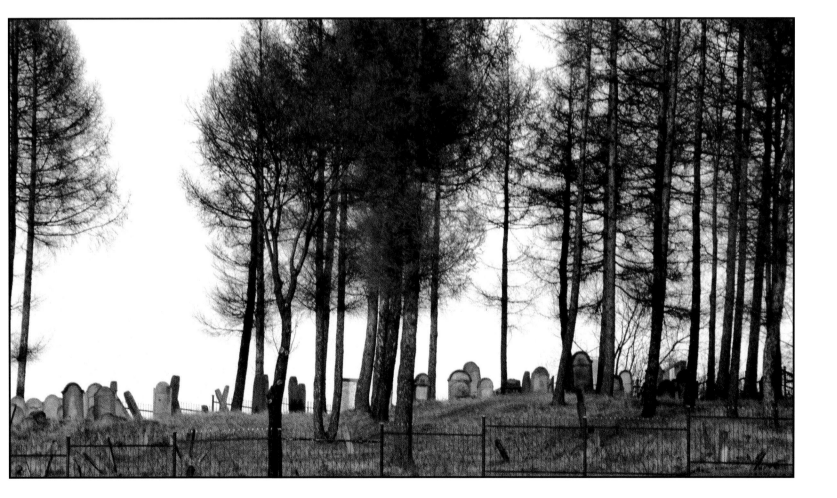

Former Jewish High School,
Nowy Sacz, Poland, 2001

The Nazis wiped out the modern Jewish society living in the larger cities as well as the more rural, traditional societies of such small towns as Nowy Sacz.

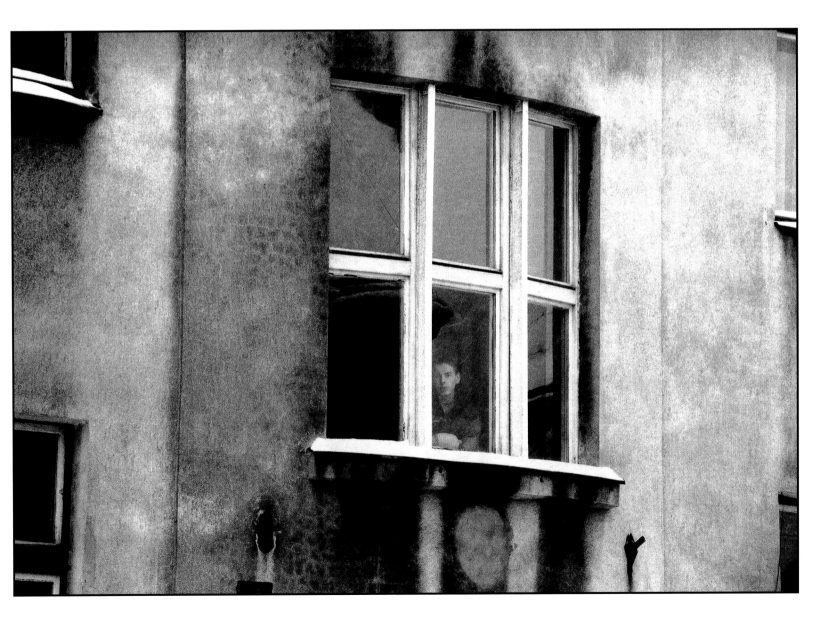

Rural Southeast Poland, Poland 2001.

Visually, the landscapes of rural Poland can evoke the sense of being frozen in time.

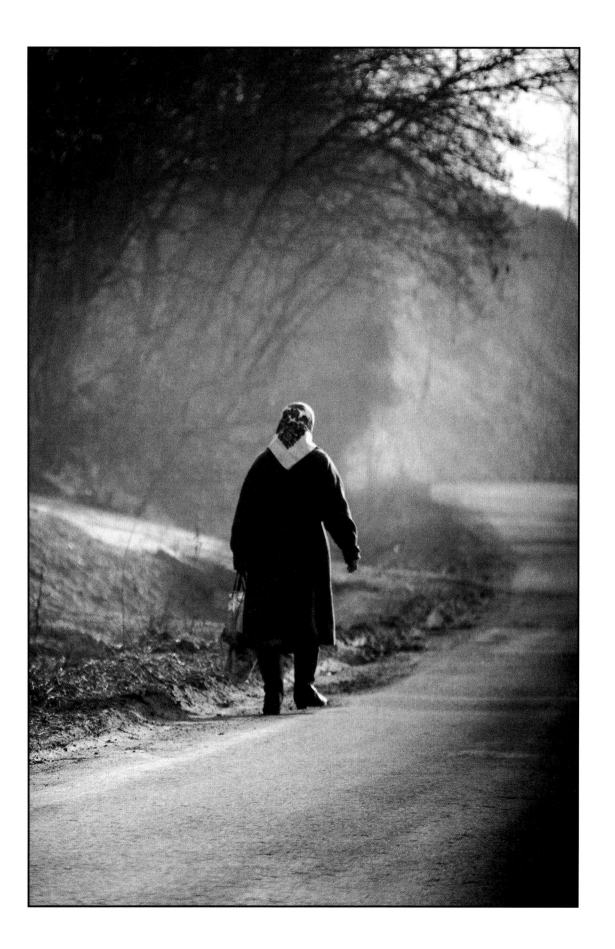

Prewar Jewish Neighborhood,
Lublin, Poland, 2001.

A plaque on a residence in this neighborhood commemorates the home where the first Passover seder was held after World War Two.

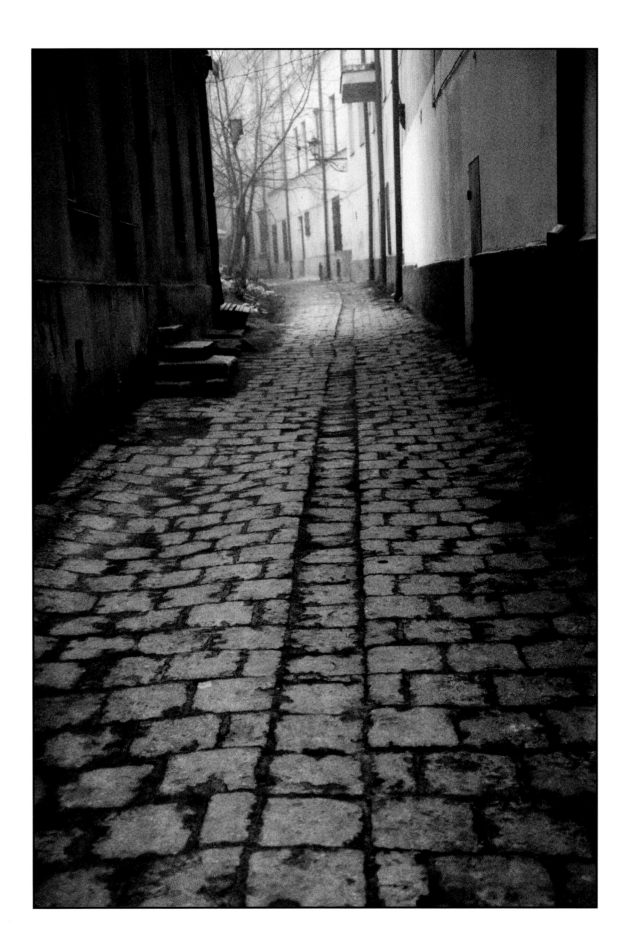

Man in the Fog, Margaret Island, Budapest, Hungary, 1995

Several hundred thousand Jewish people lived in this region and almost survived the war. Raul Hilberg wrote, in *Anatomy of the Auschwitz Death Camp*, that "All this changed radically in the spring of 1944. The cause was the invasion by Germany of its neighbor Hungary on March 19, 1944. . . . More Jews were transported to Auschwitz during the following eight months than had arrived there in the preceding two years."

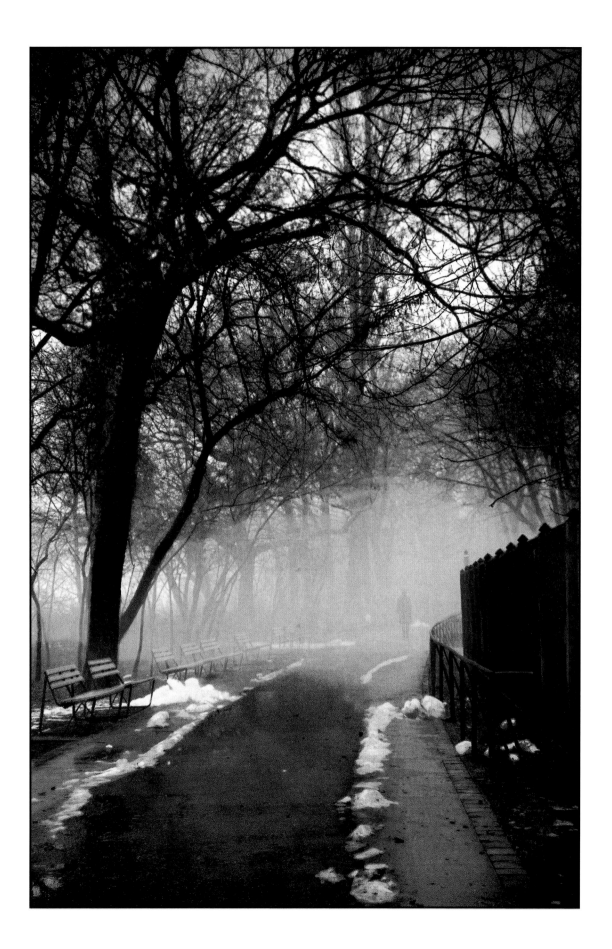

Entry to Former Sanctuary in Eighteenth-Century Synagogue Converted by Nazis to Warehouse, Przysucha, Poland, 1999

The village of Przysucha was founded in 1710. Jews were here from the beginning and this synagogue, built in 1750, was an important regional center for Jewish education and was the seat of a Jewish court of law. Mounted on an exterior wall, next to the synagogue's main entrance, is a pillory where Jews convicted by the Jewish court would be locked in punishment and publicly shamed.

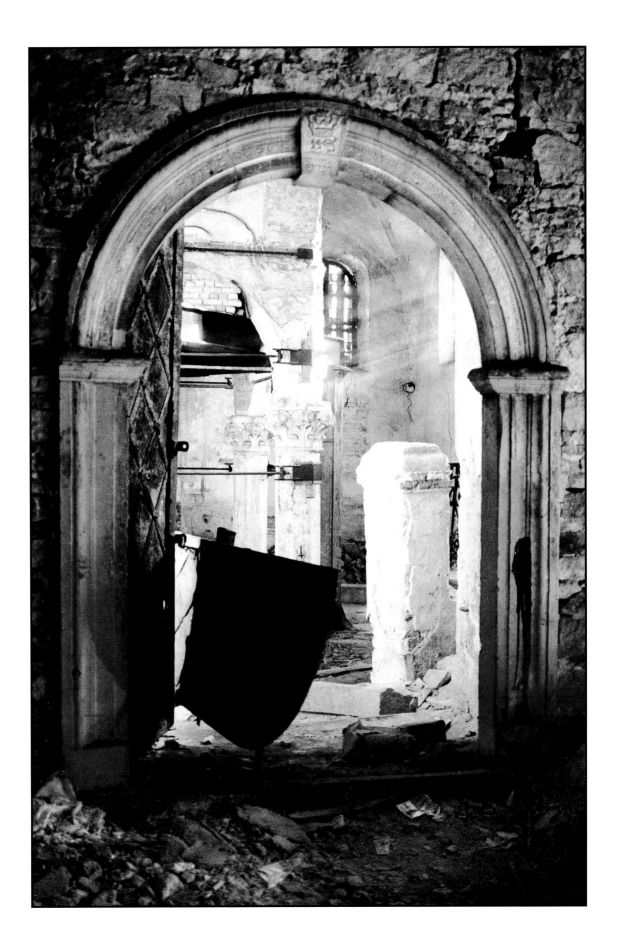

Entrance to Sanctuary in Desecrated Synagogue,
Dabrowa Tarnowska, Poland, 1999

Many multicolored frescoes are still visible on the walls of this desecrated synagogue.

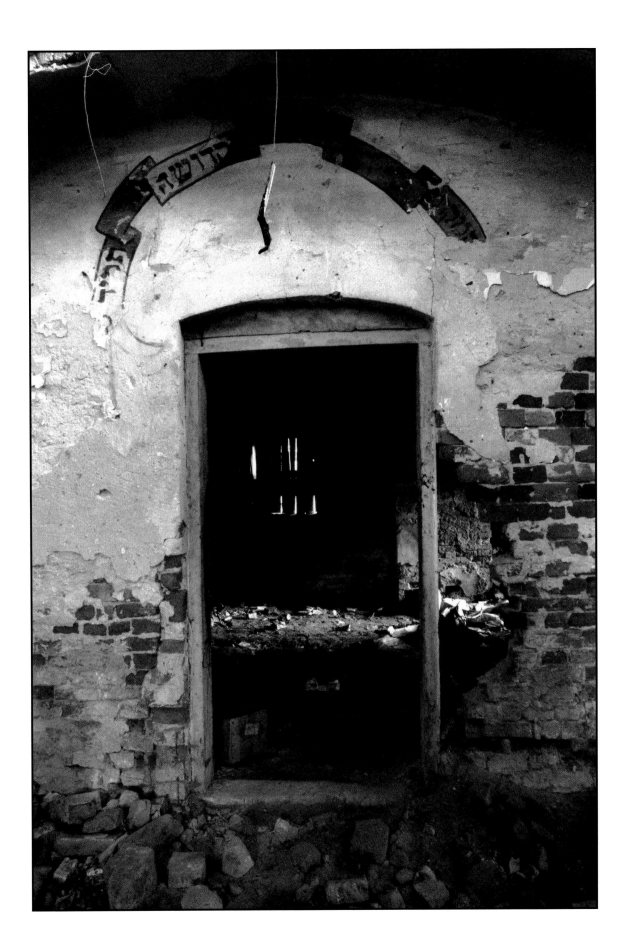

Entrance to Abandoned Nineteenth-Century Synagogue, Wielkie Oczy, Poland, 2001

This synagogue, located in a town near the border with the Soviet Union, was damaged in World War One. Its restoration was paid for by a townsman who had emigrated to the United States. The restored synagogue was then desecrated by the Nazis.

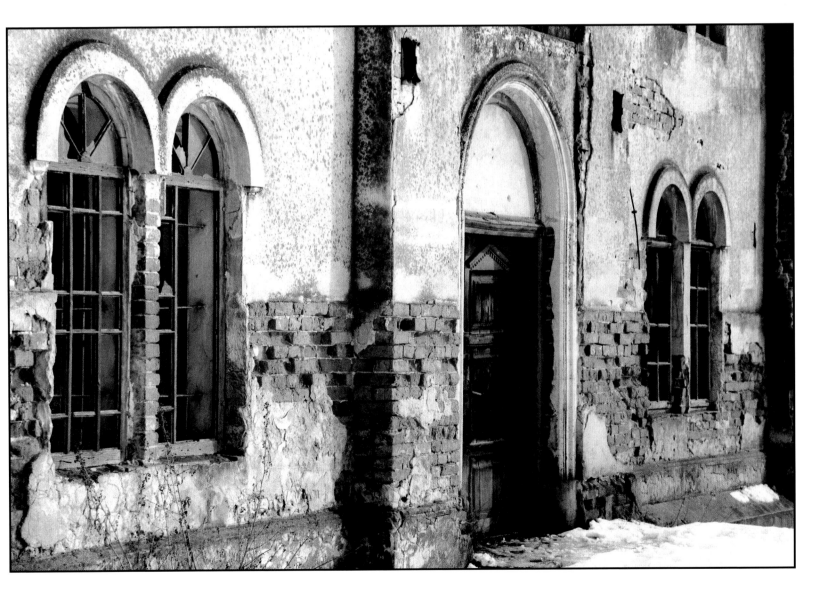

Forest as Sanctuary #2,
Rural Southeast Poland, 2001

The forest provided sanctuary to those few Jews who escaped mass-executions. Survival was difficult, but small, diverse groups, ranging from extended families with elderly grandparents, pregnant women, and infants, to bands of armed resistance fighters, lived to see the end of the war by hiding in the forest.

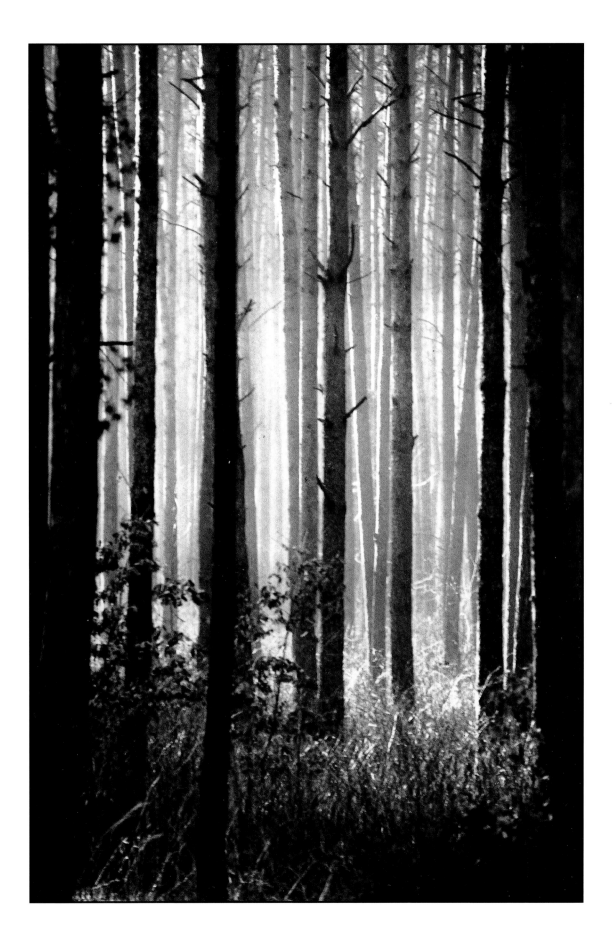

**Abandoned Jewish Dwelling in the
Former Jewish Quarter,** Cracow, Poland, 2001

Located around the corner from one of Cracow's oldest synagogues, this dwelling and the surrounding neighborhood are missing the Jewish culture which existed here in continuity for nearly a thousand years before the war.

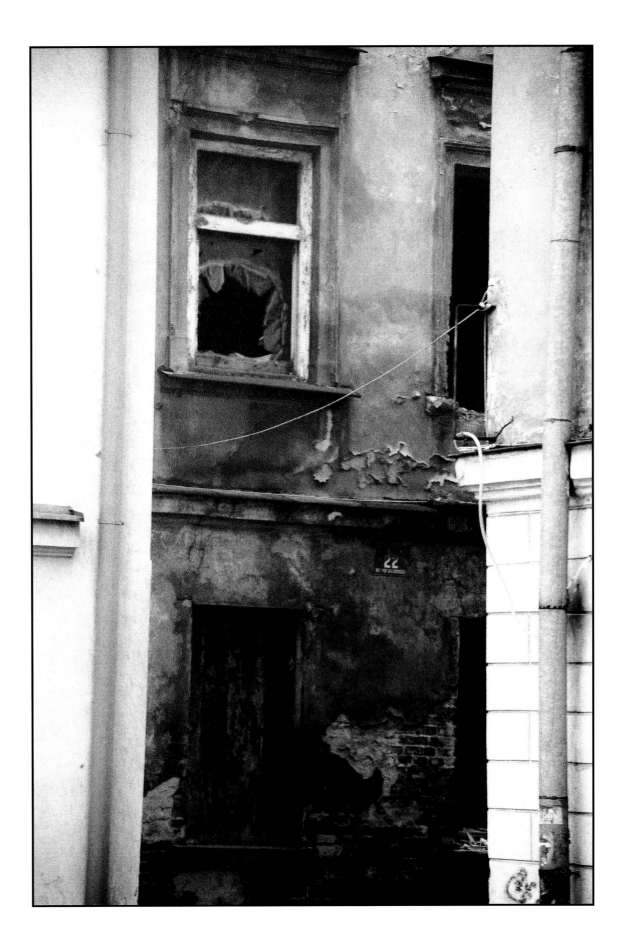

Former Jewish Street Viewed from Desecrated Synagogue, Koszyce, Poland, 2001

Trees grow through holes in the walls of the synagogue from which this photograph was taken. The homes surrounding village synagogues were typically Jewish and on the Sabbath congregants walked to the synagogue. The neighborhood well is seen in the center of the street.

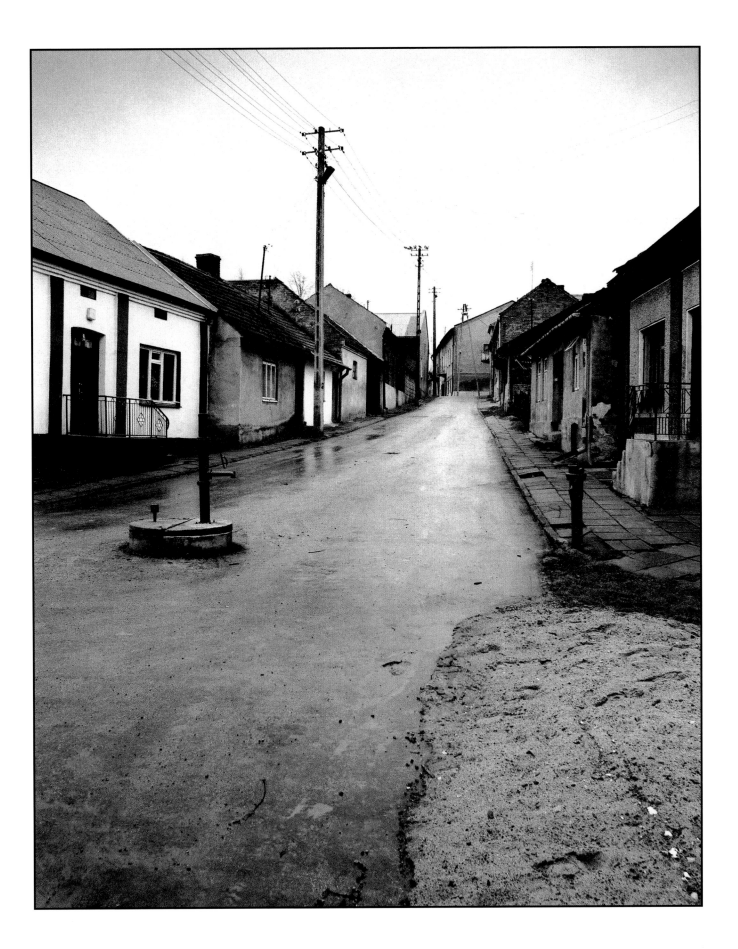

Vestige of Large Mezuzah on Nineteenth-Century Synagogue (In Use as Furniture Store), Kalwaria Zebrzydowska, Poland, 2001

This former synagogue has been converted into a furniture store.

Shop in Former Jewish Quarter,
Cracow, Poland, 2001

Many of the buildings in Kazimierz, the old Jewish district of
Cracow, remain intact but in a state of dilapidation.

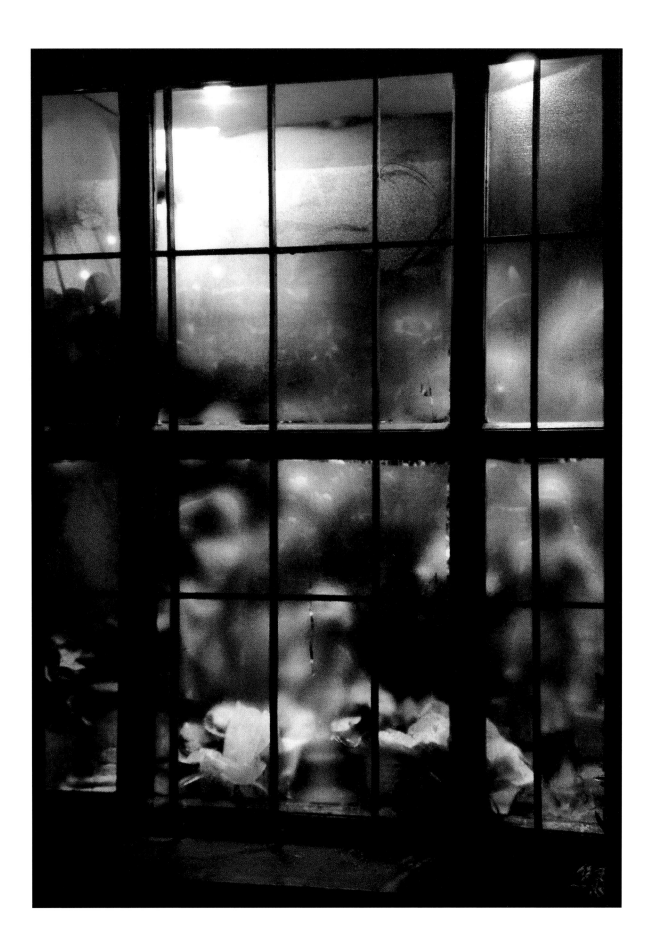

Polish Farmhouse, Rural Southeast Poland, 1996

In rural areas, as in the cities, most Jews lived within walking distance of their synagogue. A small number of Jewish farmers, however, worked the land and lived in the countryside.

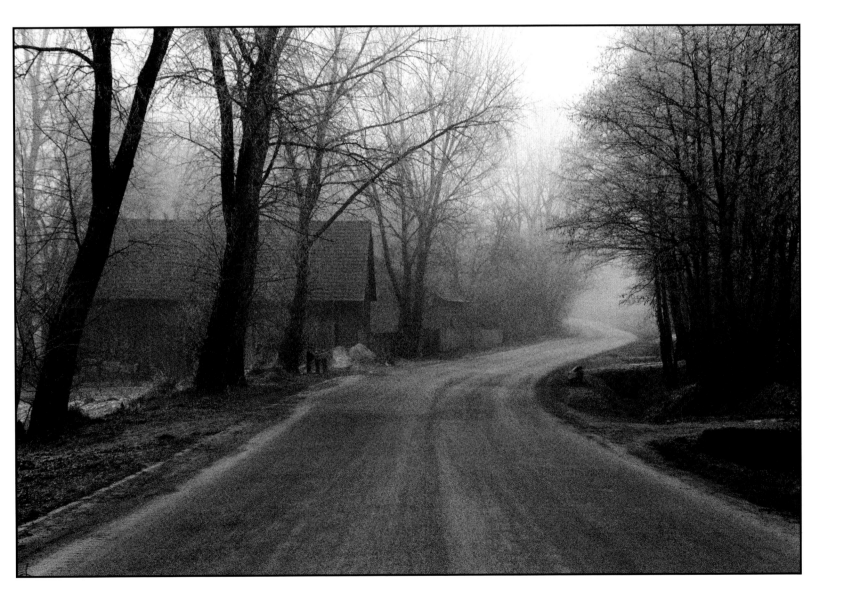

Former Jewish Residence, Dzialoszyce, Poland, 1999

Located a few blocks down the street from the town's former synagogue and Jewish school, this was once one of the more well-appointed houses in Dzialoszyce.

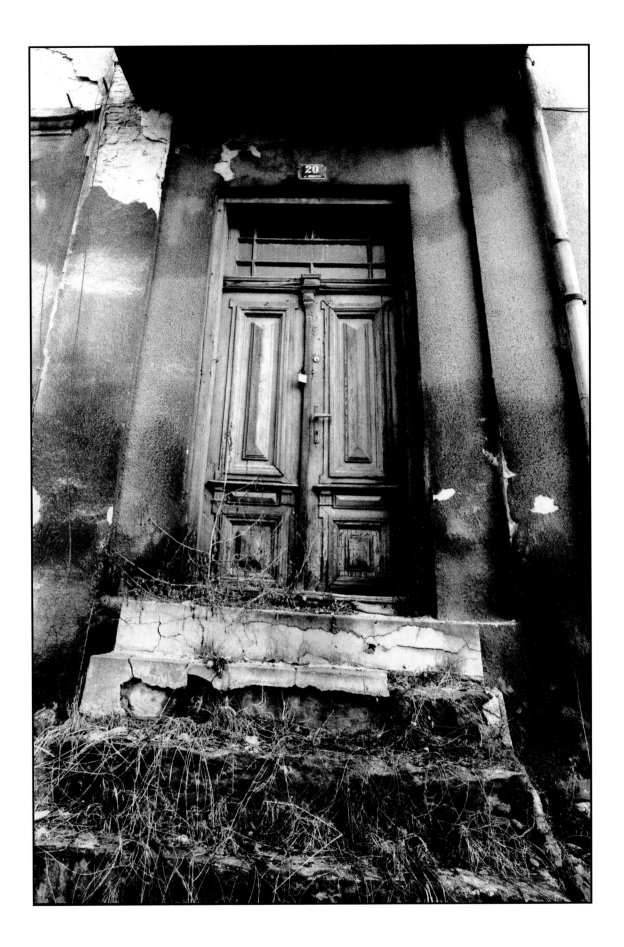

Desecrated Hillside Cemetery,
Frysztak, Poland, 1999

Located directly behind a residential neighborhood, this unmarked Jewish cemetery is a local trash dump.

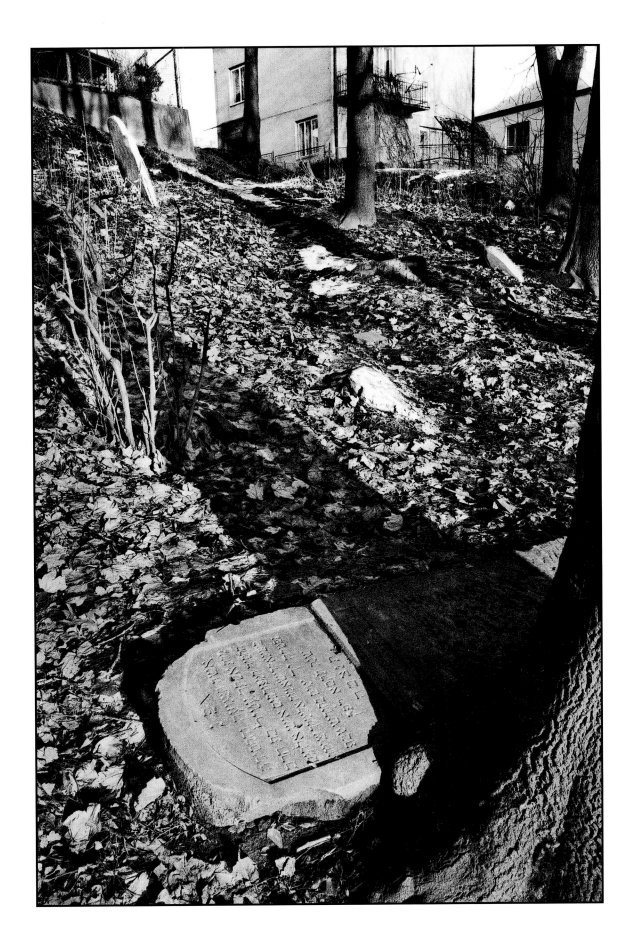

Tracks to Extinction, Cracow, Poland, 1995

These train tracks are located a few blocks from Oskar Schindler's factory, which still exists today.

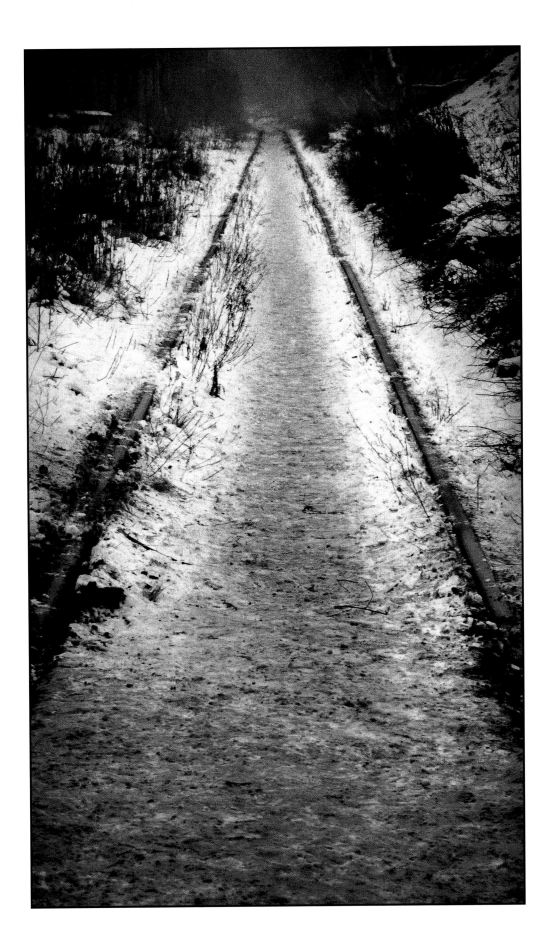

Faded Yiddish Sign of Prewar Jewish Haberdashery, Cracow, Poland, 2001

After more than six decades, this sign still retains a hint of its original colors. The shop is now a private residence.

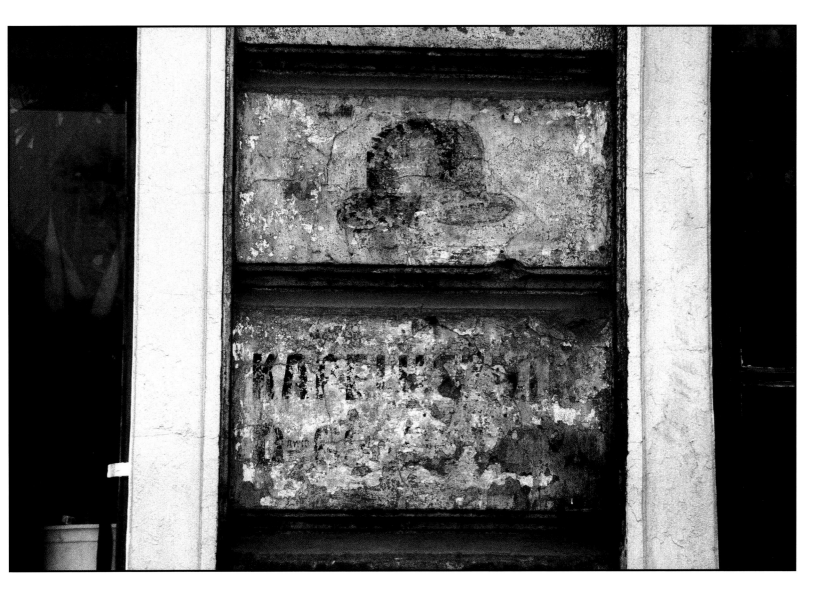

Corridor in Old Cracow, Cracow, Poland, 2001

In many residential areas of Cracow, the atmosphere of community life before the Holocaust can easily be imagined. The architecture and visual charm of these neighborhoods has changed little in the nearly six decades since the end of Nazi domination.

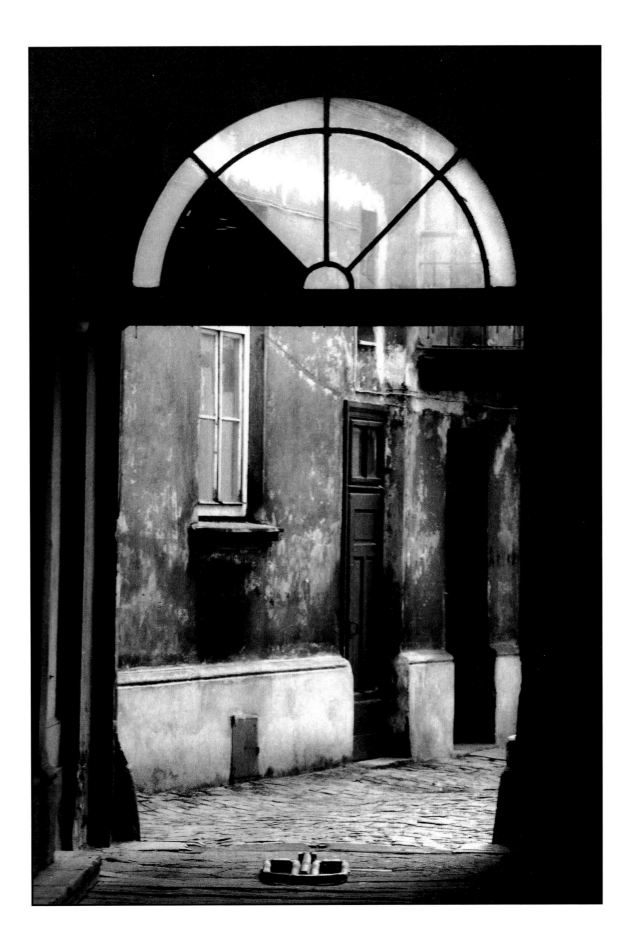

Entrance to Hilltop Cemetery,
Bobowa, Poland, 1996

Just to the right of this gate is a mass grave where Jewish residents of the village were executed and buried by the Nazis.

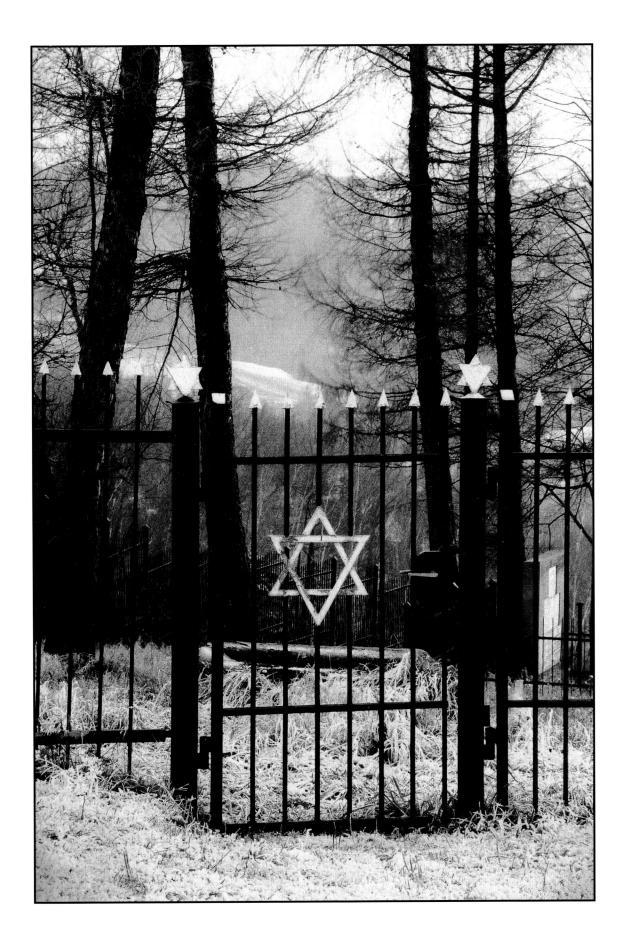

Synagogue at Night, Budapest, Hungary, 1995

When this photograph was taken the Dohany Utca Synagogue was the largest active synagogue in Europe. Its doors were first opened in 1859.

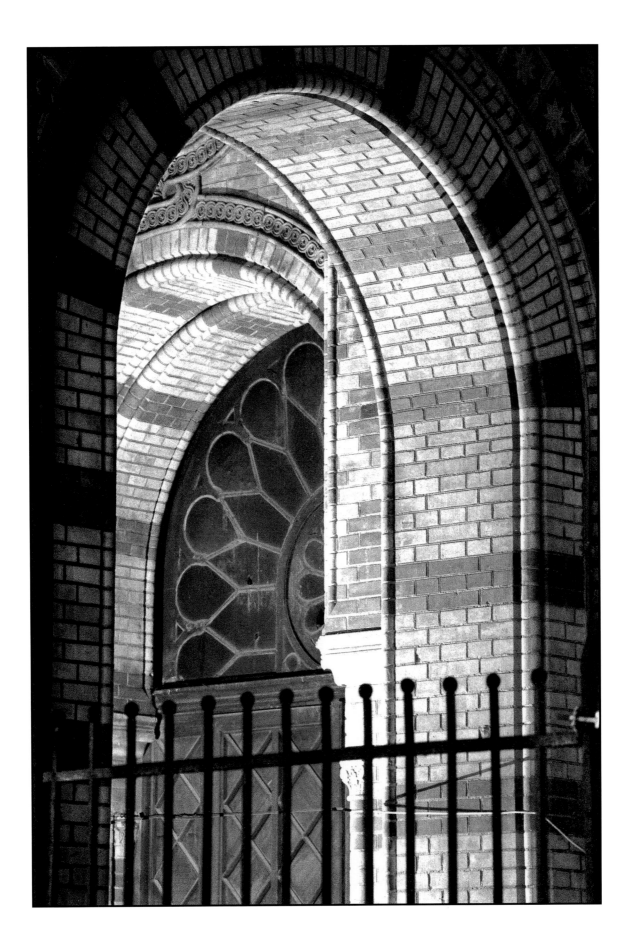

Factory across from Auschwitz Formerly Operated by Slave Laborers, Auschwitz, Poland, 2001

The Nazis encouraged German industrialists to build factories close-by the concentration camps, promising an abundant supply of slave labor.

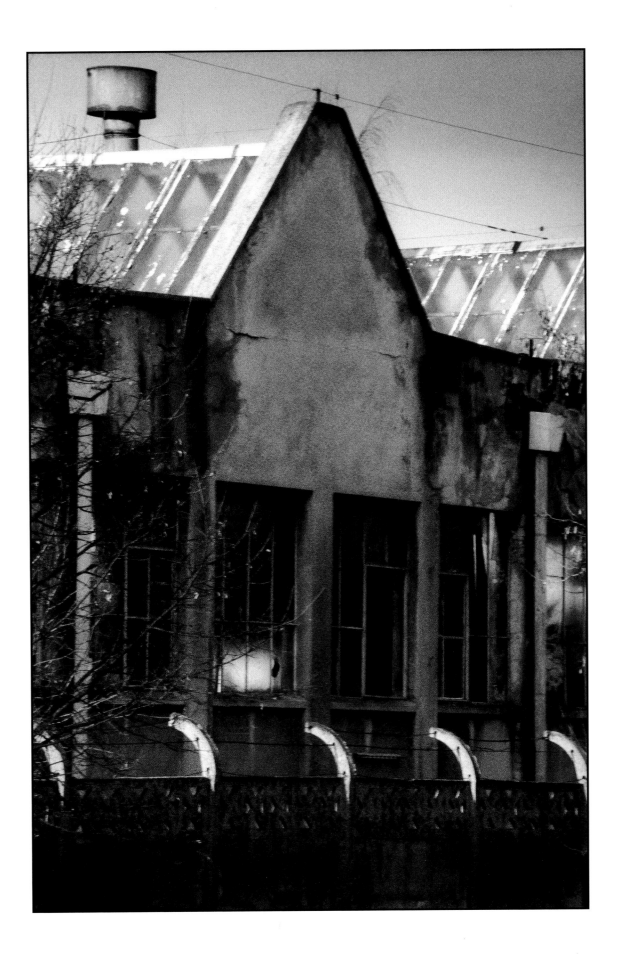

Gates to Ogrodowa Street Slave Labor Camp,
Lublin, Poland, 1999

The gates of this labor camp remain in the heart of Lublin.
A five-star hotel and major university are very close by.

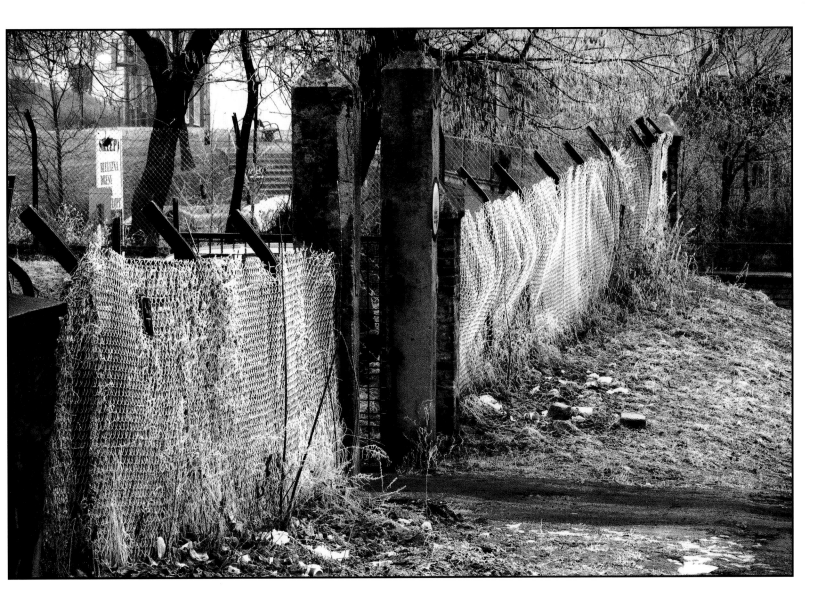

Former Jewish Marketplace and Kosher Abattoir,
Cracow, Poland, 1996

Built in the nineteenth century, this was the main kosher butchery for Jewish Cracow before the war. Meat is still sold here.

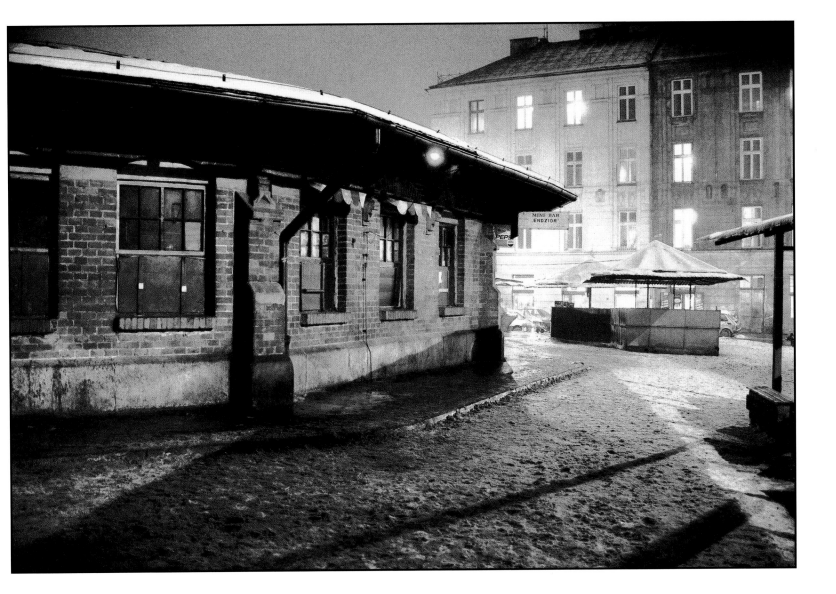

Where the Children Played,
Margaret Island, Budapest, Hungary, 1995

Many Jewish families lived here before the war and enjoyed the pleasures of this park. In Budapest and other major Eastern European cities, Jews comprised a large percentage of the civic leaders, professors, doctors, lawyers, scientists, bankers, journalists, and artists.

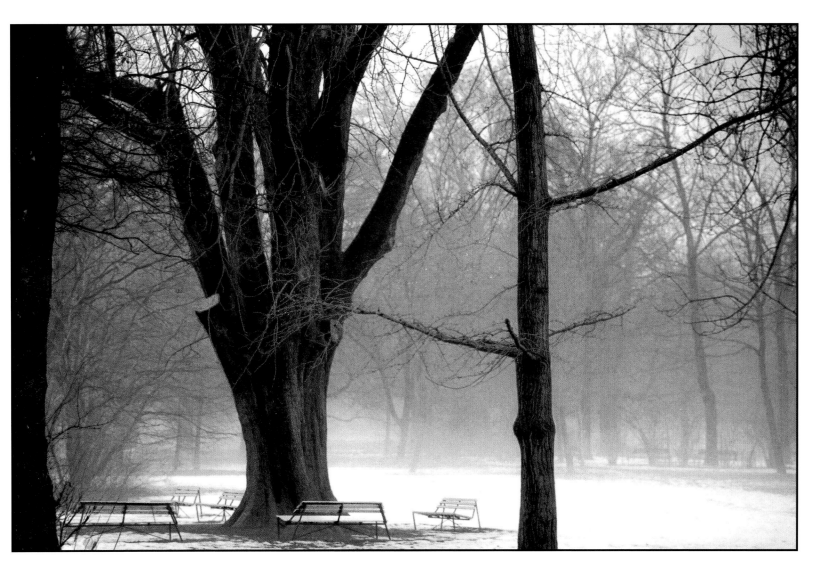

Torah Niche in a Desecrated Synagogue Converted to a Warehouse, Wodzislaw, Poland, 1999

This niche in the eastern wall of the synagogue was where the Torah scrolls were kept.

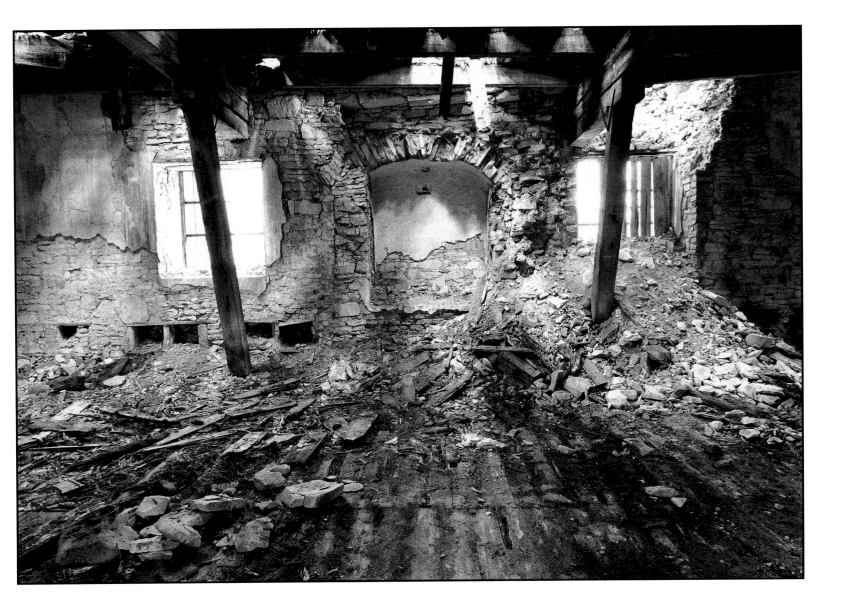

Auschwitz in Winter #2, Auschwitz, Poland, 1996

Used as a Polish military installation before the war, Auschwitz has a campus-like appearance.

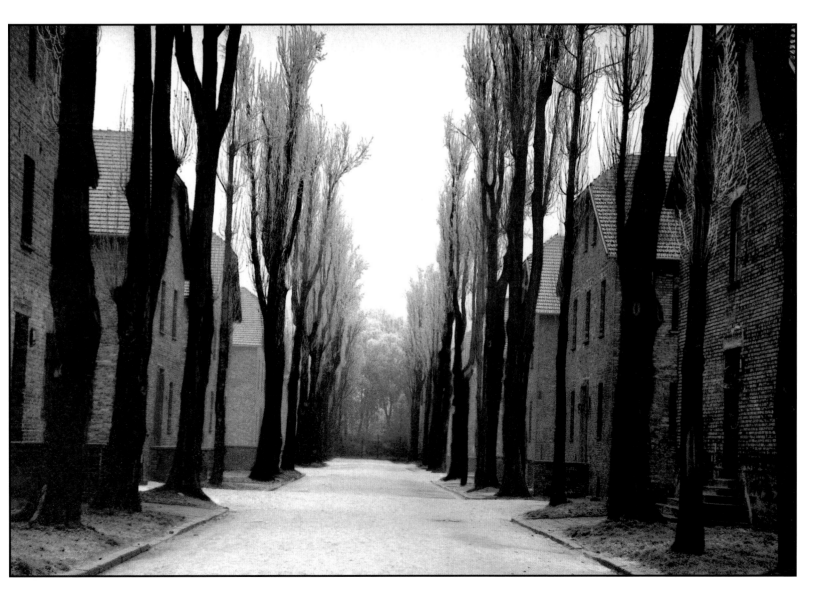

Torture Chamber Door – Auschwitz,
Auschwitz, Poland, 1995

In late summer 1941, behind this and adjacent doors, an experiment was carried out using the fumigant Zyklon B: six hundred Russian soldiers and two hundred sick prisoners were murdered. Gassing thereafter became the favored method of mass-murder by the Nazis.

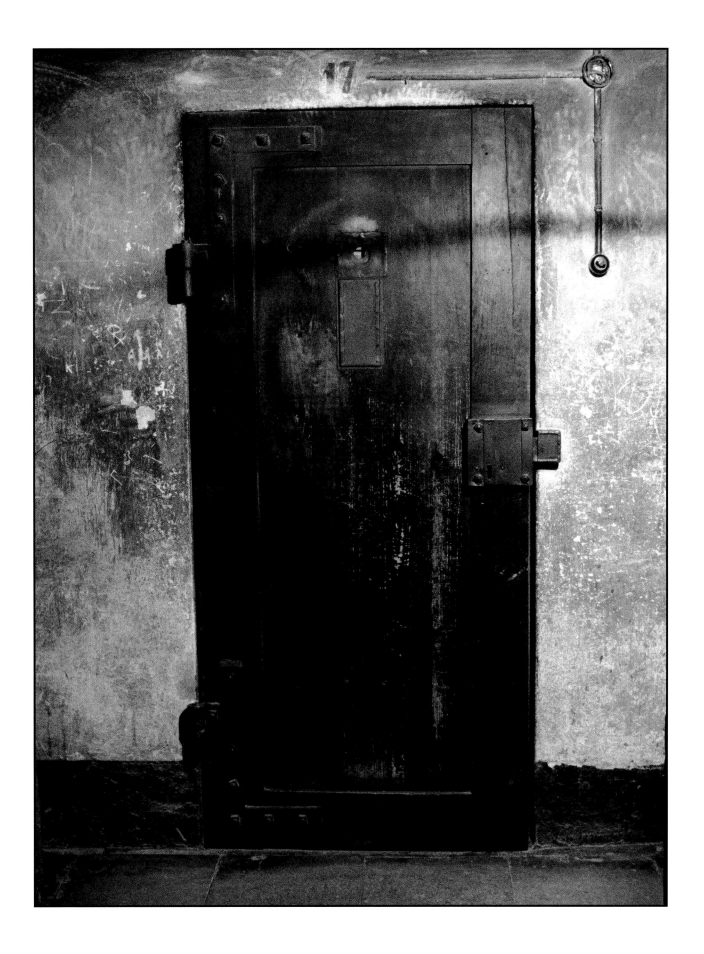

Zyklon B Gas Canisters - Majdanek,
Lublin, Poland, 1999

Killing cockroaches required the use of the costly and concentrated Zyklon D. Killing people was accomplished using the weaker, less costly version of the product, Zyklon B.

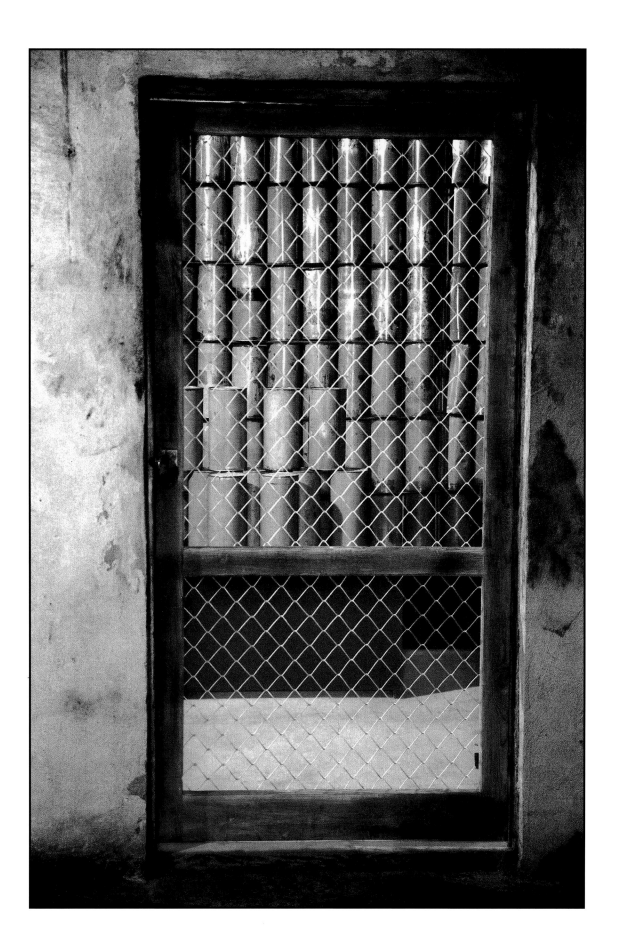

Killing Room – Auschwitz, Auschwitz, Poland, 1996

People were killed in this room, one at a time. The disinfectant phenol was injected directly into the heart through a long, intracardiac needle.

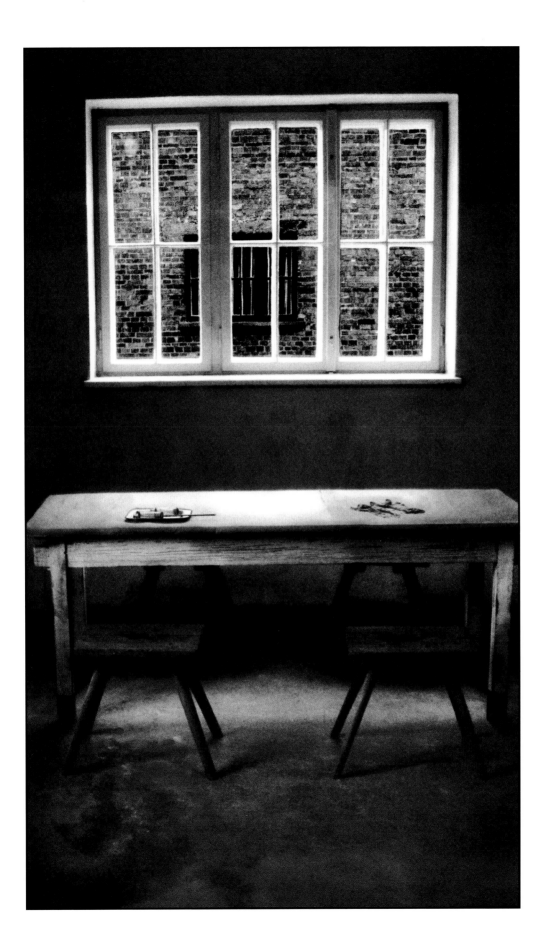

Birkenau Silhouette, Auschwitz, Poland, 1996

A cloud of ground fog passed in front of Birkenau as this photograph was taken in December, 1996.

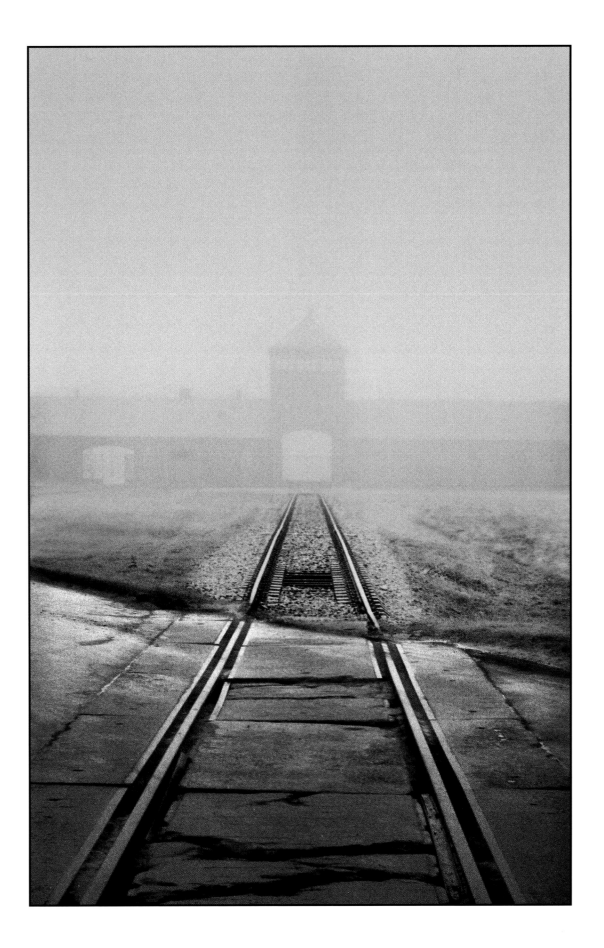

Descent into Gas Chamber #3 – Birkenau,
Auschwitz, Poland, 2001

Initially designed to kill 1,440 people per day, the killing capacity of this gas chamber was nearly doubled by decreasing the incineration time of the corpses to twenty minutes and by cremating three bodies at a time in each oven.

Entrance to Gas Chamber #1 – Auschwitz,
Auschwitz, Poland, 1996

This gas chamber could kill more than seven hundred people at once.

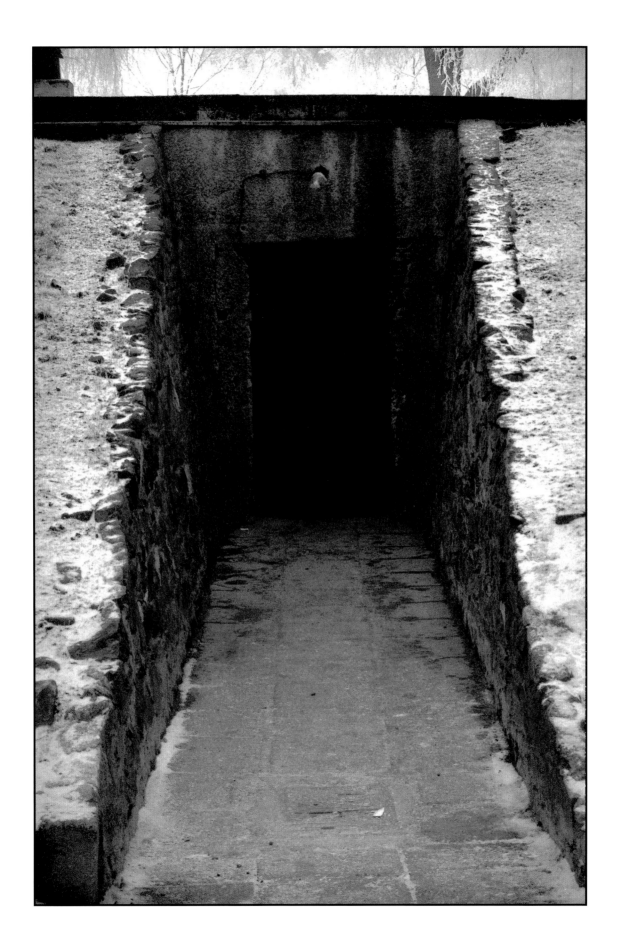

Corridor in Kazimierz (Former Jewish District),
Cracow, Poland, 1996

A scene in the movie *Schindler's List* was filmed here. A young boy heroically saved the mother of a little girl who was his friend by hiding her under an outdoor stairway located at the edge of this image.

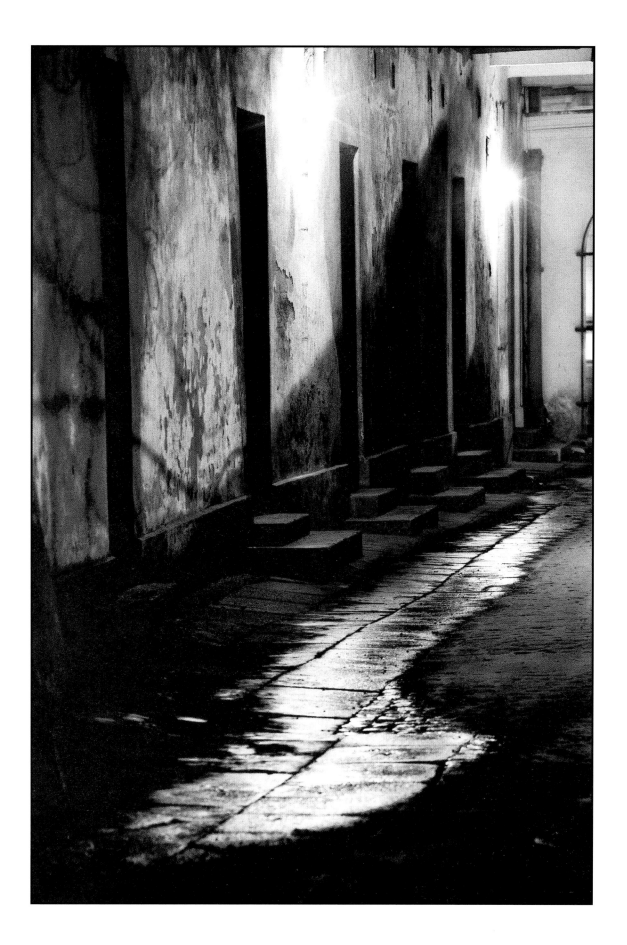

**Front Yards of Formerly Jewish Homes Next
Door to Synagogue in Use as Auto Repair Shop,**
Olpiny, Poland, 2001

Olpiny is one of the more isolated villages in Poland.

Former Jewish Shop, Dzialoszyce, Poland, 1999

Located adjacent to the former synagogue and Jewish school, this remains a small food store.

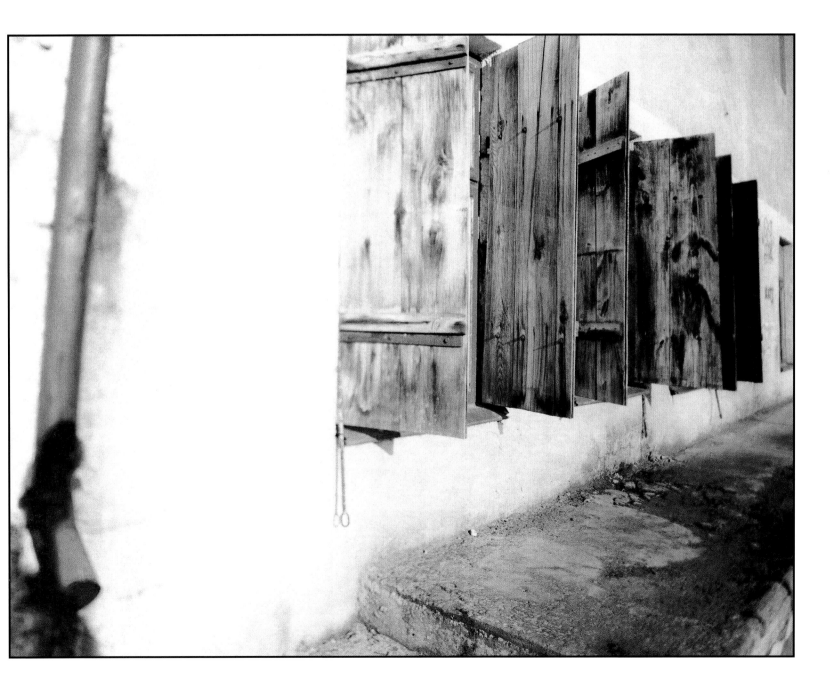

Park in Former Jewish Enclave,
Wodzislaw, Poland, 1999

Jewish homes and businesses once surrounded this park. The former synagogue, now a barnyard and trash dump, is located a few blocks away.

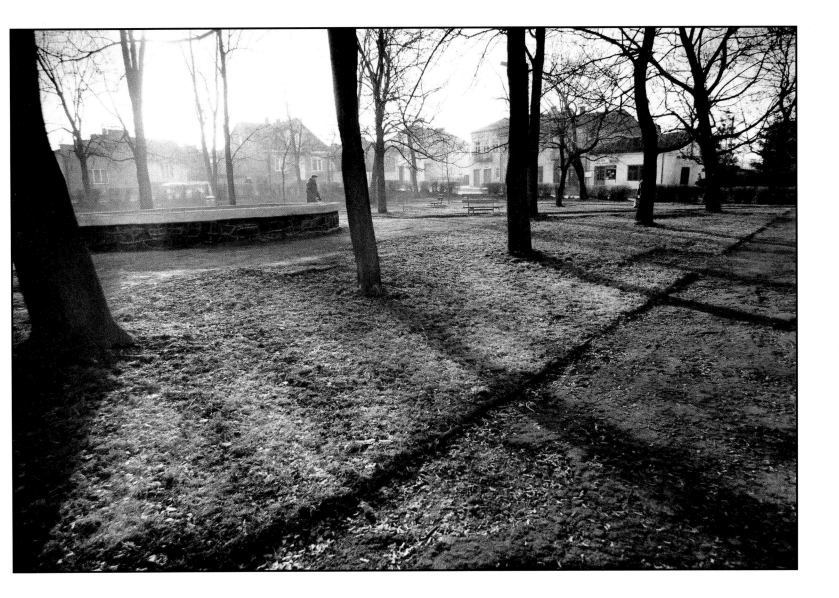

Former Jewish Candy and Ice Cream Store,
Tuchow, Poland, 2001

This formerly Jewish-owned confectionary is a few blocks away from the entrance to the wartime Jewish ghetto where Jews from the surrounding region were incarcerated.

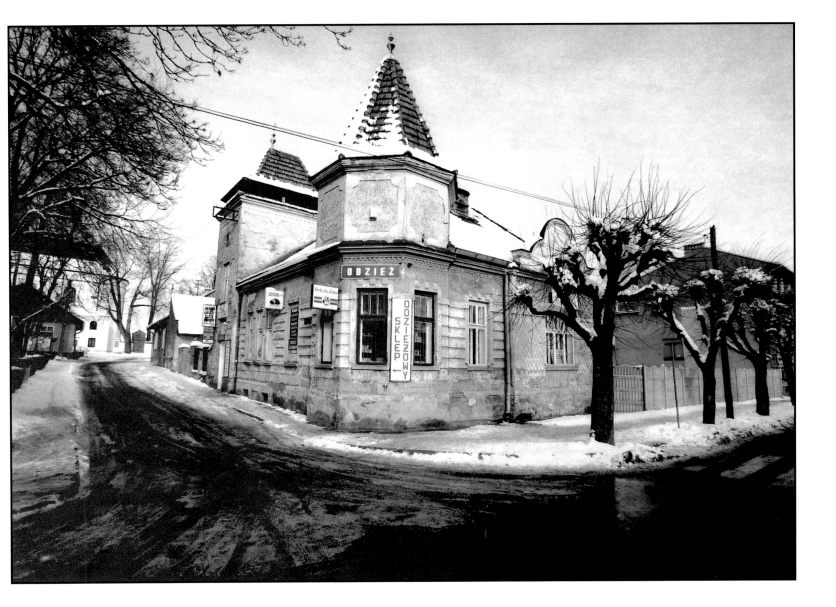

Roofless Synagogue and Jewish School,
Dzialoszyce, Poland, 1999

This former synagogue is located in a poverty stricken residential neighborhood.

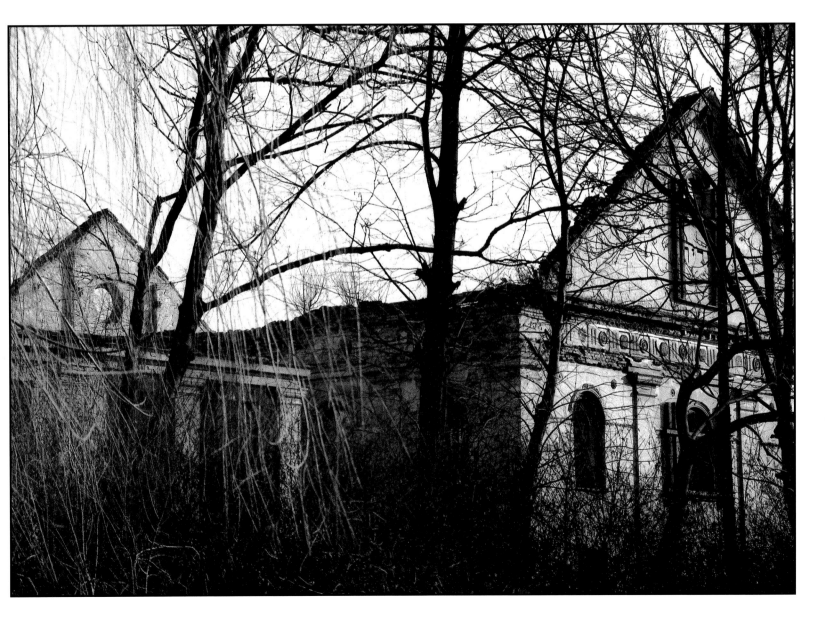

Synagogue Converted to Warehouse – Now in Ruins,
Koszyce, Poland, 2001

Built in the early 1930s, this synagogue is now abandoned.
When this photograph was taken several large piles of bricks
lay on the wooden floor of the sanctuary where the exterior
wall had collapsed.

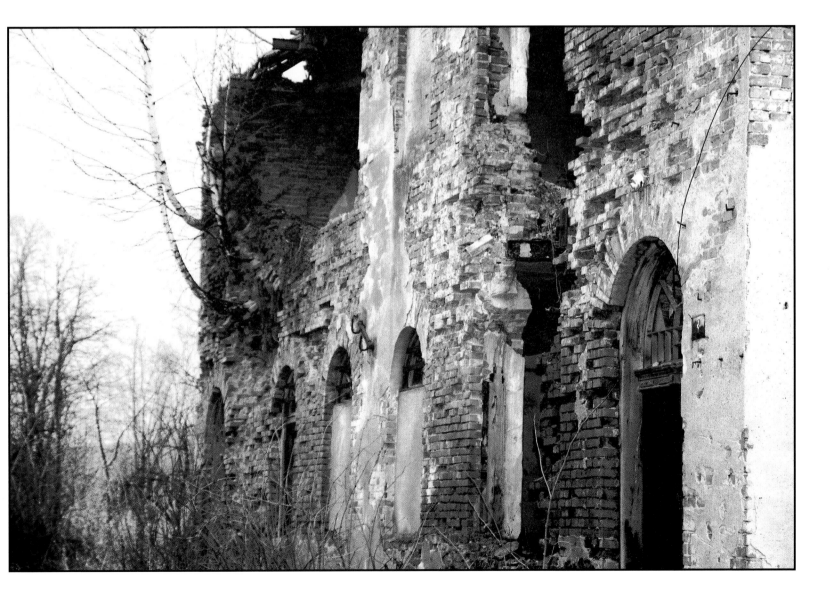

ACKNOWLEDGMENTS

In December, 1996, just before leaving on my second trip to Poland, a fortuitous lunch took place at Eatzi's in Dallas with my beloved friends, Bryan Woolley and Isabel Nathaneal Woolley. They suggested that I seek to publish a book of these photographs. They have steadfastly nurtured me and the project at critical points from inception to the present. I'm honored to know them and to call them friends.

Reid Heller, my closest friend, deserves enormous credit. He has provided unflagging support and has unselfishly shared his time and his amazing mind and has helped me to gain a better understanding of the historical, political, and aesthetic considerations of these photographs.

Renata Zwodzijasz ultimately made this project possible. Renata showed me a world of obscure, hard-to-reach places in the Polish countryside with many historical treasures untouched since the war. She played the role of history sleuth, often uncovering important photographic sites through interviewing older people who were eye-witnesses to Nazi tyranny. Her warmth, affability, and intelligence created allies and opened doors virtually everywhere we went. Enduring long days and inclement weather, she and her family sacrificed time and inconvenience to help me create these photographs.

My mother, Stephanie Gusky, passed away in June, 2002. She was very proud of this project and gave me support and encouragement from the start. I only wish that I could share the joy of the book's completion with her in person.

In February, 2001, I met the freelance editor, Bonny Fetterman. Bonny opened many doors for me and introduced me to my publisher Peter Mayer and my literary agent, Georges Borchardt.

In the course of this project, I met Luisa Kreisberg, the founder of the Kreisberg Group, a cultural public relations firm in Manhattan. Luisa has adopted me as a surrogate son. Her love, her courage, and her guidance have changed my life. Luisa has given me strength at critical times and challenged me to continue to photograph.

Two Dallas friends have played an important role in the project from its inception. Photographer Ann Parks and Jennifer Castro have put their heart into helping me to succeed. I will always remember and appreciate their candid critique of the photographs and their encouragement.

I'm grateful to independent curator and author Allon Schoener. His guidance and candor have been critically important at key junctures in the production of this book. I feel tremendously fortunate to know him and value his mentorship.

Thanks to Mort Meyerson and his cousin, Manhattan-based freelance editor Susan Schwartz, for opening doors in New York City. Through Susan, I met Bonny Fetterman.

Thanks to my aunts Rita Gusky and Irene Snyder for their support and help along the way. The encouragement and feedback from noted Manhattan photographer and teacher Harvey Stein has been greatly appreciated.

Thanks to my talented friend, fine art black-and-white photographer Chip Forelli (one of my favorite living black-and-white photographers) for his inspiration and encouragement.

Thanks to Norm Levy and Mediastreet.com for providing breakthrough photographic paper which has helped me to realize my creative vision.

I thank the following people who contributed in various ways to the book: Dr. Greg Skie who inspired my original interest in black-and-white photography, Dr. Harvey Richman, Dr. Rick Brettell, Gary Hatcher, Duane Johnson, Joan Davidow, Gerry Hurst, Pat and Ray Patton, Roger Moore, Bernie Rosenberg (who translated the Hebrew inscriptions in "Multicolored Fresco of Lion in Roofless Seventeenth-Century Synagogue"), and Gordon Parks.

I'm grateful to Judith Miller for writing the introduction. I've long admired her courageous reporting.

Special thanks to my publisher Peter Mayer for embracing this project, to my editor Caroline Trefler, and to production manager George Davidson for guiding me through the creation of my first book of photographs. It has been a privilege to collaborate with them and I've learned a lot.

My literary agent Georges Borchardt and his assistant, Hope Richardson, have been exceedingly patient with me as a new author. I'm grateful.

Finally, I'm also grateful for the abiding support of my friend Angie. I thank her for caring deeply about the completion of this book and for her sensitivity to the lives of the people who once populated the places depicted in these photographs.